IMAGES
of America

MIFFLINBURG AND
THE WEST END

D1597177

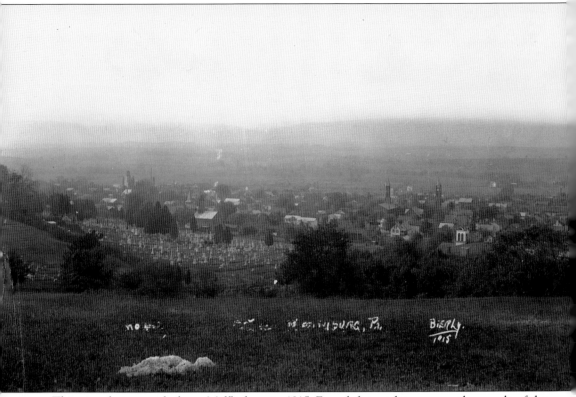

This view facing north shows Mifflinburg in 1915. From left to right, one sees the cupola of the Mifflinburg Academy, the tower of the Mifflinburg Body Company, the steeple of the Presbyterian First Church, the steeple of the Elias Church, the original spire of the German Reformed Church (destroyed by lightning in 1916), and the tower and clock of the First Lutheran Church. In the right foreground, the cupola of the high school rises above the trees. Buffalo Mountain rises to the north and looks over the valley. The valley becomes increasingly narrow farther west. (UCHS JD.)

ON THE COVER: Farming has always been a mainstay of Union County's economy. John Watson was a Scottish immigrant whose family settled in West Buffalo Township by 1790. The barn, built in 1876 on Watson Green Meadow Farm, was the largest in Union County of this style, and neighbors gathered to watch the first metallic windmill catch the breeze when it was first erected. The photograph dates to about 1903. (Courtesy of John Dersham from the Cora Shoemaker Watson Collection.)

IMAGES
of America

MIFFLINBURG AND THE WEST END

Marion Lois Huffines

ARCADIA
PUBLISHING

Copyright © 2012 by Marion Lois Huffines
ISBN 978-0-7385-9212-1

Published by Arcadia Publishing
Charleston, South Carolina

Printed in the United States of America

Library of Congress Control Number: 2011934995

For all general information, please contact Arcadia Publishing:
Telephone 843-853-2070
Fax 843-853-0044
E-mail sales@arcadiapublishing.com
For customer service and orders:
Toll-Free 1-888-313-2665

Visit us on the Internet at www.arcadiapublishing.com

CONTENTS

ACKNOWLEDGMENTS

Tony Shively answered many questions, traveled to sites to verify identifications, loaned photographs, proofed captions, and with great kindness researched mysteries and offered further information.

Judith Blair generously traveled around the West End with me, pointing out the highlights I was interested in and hiking all the way to Butter Rock.

Bronwen Sanders was generous in loaning photographs from the Mifflinburg Buggy Museum collections and sorted out for me the many threads weaving the story of buggy-makers in Mifflinburg.

Jack Fisher researched deeds of the Mifflinburg Buggy Company and the Silk Factory and resolved questions regarding the Kistler family and the Bowersox farm.

Alan Richard scanned the photographs, offered help in locating images for the project, and used his exceptional skill to achieve the greatest clarity possible for each photograph.

Carl Catherman carefully proofed captions and generously provided further information. Betsy Robertson, of Robertson Public Relations, edited all textual parts of the project. Darcy Mahan and Abby Henry, of Arcadia Publishing, answered questions and encouraged me to meet all deadlines.

I also acknowledge the help I received from the many people who offered their photographs, memories, and information, including the following: Richard Benjamin, William Clemens, John Dersham, Kenneth Erdley, David Goehring, Eleanor Hoy, Jeannette Lasansky, Robert Lynch, Carol Manbeck, William Mattern, Linn Mensch, Judy Moyer, Ronald Nornhold, Kim Ranck, Eleanor Rawitz, Thomas Rich, Carol and James Schwartz, Duain Shaw, Joannah Skucek, Linda Estupinan Snook, James Walter, Debra Wilson, Elaine Wintjen, Glen Zimmerman, and Jeanne Zimmerman.

Unless otherwise noted, images in this volume appear from the following collections and are indicated as noted below:

Union County Historical Society (UCHS, followed by an identification number)
The UCHS John Dersham Collection (UCHS JD), from the original glass negatives
Marion Lois Huffines (MLH), private collection
The Mifflinburg Buggy Museum, Snyder Collection (MBM SC)

INTRODUCTION

The Buffalo Valley to the east widens generously along the Susquehanna River where Union County's river towns were settled early and reaped the advantages of trade through river and canal transportation. The valley itself lies like a funnel on its side from east to west and narrows toward the west until Paddy Mountain and White Mountain close it off, allowing only Penns Creek entry to flow eastward. The valley west of Mifflinburg is referred to as the West End (of Union County); it narrows precipitously at the village of Weikert and westward, and that area is also referred to as the Tight End. There, Union County meets the border of Centre County. Mifflinburg and each of the towns of the West End have a story to tell. The hard work of making a life in early America demanded courage and determination of its settlers. There were good times when the towns thrived and tough times when efforts failed. Fires and accidents destroyed dreams, and financial distress halted progress, but the towns worked hard to survive. Those that did celebrated their successes with fairs, parades, bands, and church dinners.

Mifflinburg began as two settlements. Elias Youngman laid out Youngmanstown in 1792 and soon sold 32 town lots to settlers and donated other lots for a church, school, and cemetery. George Rote laid out Rotestown (or Rhodestown) to the east in 1797. The towns merged in 1827, and the seam of the merger is still visible today at Third Street where east-to-west roads bend. The merged town of Mifflinburg, named for Pennsylvania's first governor, Thomas Mifflin, served briefly as the county seat. As the town grew, shops, stores, and businesses opened and closed as the financial winds changed. Some businesses established themselves successfully for quite a long run. These businessmen rewarded themselves by erecting large mansions as their homes, which still line the streets today. The second half of the 19th century took an unexpected turn. When Thomas Gutelius opened a buggy shop in 1846, he began a buggy industry that ultimately sold its products across young America and spawned hundreds of supply houses and specialty shops. Over time, there were about 90 separate buggy-making businesses in Mifflinburg. The buggy industry thrived until the advent of the automobile, when many buggy companies shifted to building bodies for cars, trucks, and trailers, an enterprise that lasted until 1941. By then, Mifflinburg was well established. Its reputation had earned it the moniker "Buggy Town," still used today to promote tourism.

Col. Thomas Hartley laid out the town of Hartleton in 1798. The town was situated on the first public road, the Reuben Haines Road, later called the turnpike, which led through Buffalo Valley east to the West Branch of the Susquehanna River. A tavern marked the way for travelers passing through, as did a couple of inns. Because the railroad passed it by, opting to follow Penns Creek to the southwest, Hartleton developed more slowly than the other towns of the West End in that period. In 1841, the first church was built, a Union church for all denominations. Hartleton blossomed in the age of the turnpike, providing respite along the tiresome journey to Aaronsburg and on to Bellefonte. The turnpike invited business activity, and by 1840, Hartleton had three taverns and three stores. It incorporated as a borough in 1858, and in 1890, the population grew

to 261. Most settlers were farmers. Its population remained stable over the next century. It sported two one-room schoolhouses, which later merged into a two-room, two-story schoolhouse; it also had its own literary society and a brass band.

Laurelton, founded in 1811 and earlier known as Slabtown, became Laurelton in 1856. By that time, the town had erected two churches, enlarged a gristmill, and sported Joseph Raudenbush's Palace Store and West End Hotel. Laurelton's economy was based on lumbering operations of the late 1800s and early 1900s. The Laurelton Lumber Company ran a narrow-gauge track through Laurelton to Paddy Mountain in 1895. Mark Halfpenny and Son operated the Halfpenny Woolen Mills in 1841 until it was destroyed by fire in 1866. Halfpenny rebuilt in Lewisburg. In the 1920s, Laurelton State Village for Feeble-minded Women of Childbearing Age opened, an institution that met the needs of society's changing approach to mental retardation. Laurelton Center, as it was later called, closed its doors in 1998. Laurelton is also the site of Union County's West End Fair. Established in 1925, the fair attracts thousands of visitors every year.

The Lewisburg, Centre & Spruce Creek Railroad favored the path along Penns Creek, and during 1872–1873, a siding at what became Swengel was added and then pushed on to Millmont. Two miles beyond Millmont at Weidensaul's Mill, the railroad provided a whistle stop, which was called Laurel Park. Each of the towns profited from its location along the rail line. Swengel soon erected a depot, a post office, and several other buildings. Millmont also built its depot and solicited funds for a church. Residents of these towns provided the labor force for the growing timber industry, and families often took in boarders who arrived from other areas. The Whitman Steele Lumber Company operated in Laurel Park until 1909. In May 1904, the main flywheel of the mill flew apart, killing one workman and injuring others. A fire on December 14, 1907, fully destroyed the mill. The company limped along, but the timber of the virgin forests was almost gone. Laurel Park was never the same, its reason for being having been traded for thousands of feet of lumber from the forests no longer there.

The Lewisburg, Centre & Spruce Creek Railroad also spawned Glen Iron, where a siding served the Berlin Furnace. A depot and two stores soon followed. The economic difficulties of 1873 stopped further building of the railroad, and until 1876, Glen Iron was the end of the line. The main attraction for the railroad stockholders was the iron mines along Penns Creek and the furnace at Glen Iron, which dated back to 1820 when David Beaver built an iron forge onto his sawmill and attracted iron manufacturers Charles and Clement Brooks from Chester County. The brothers erected a furnace, calling it Berlin Iron Works, on the south side of Penns Creek. The furnace was never very profitable, and the iron ore itself not of high quality. The arrival of the railroad revived for a time what was later called the Glen Iron Works, but it foundered, revived, foundered again, and closed in 1892. In 1901, John T. Church tried again and named the operation the Glen Iron Furnace Company, but it was destroyed by fire in 1903. Nothing of it remains today.

Timbering also gave rise to Weikert. Bounded in the Tight End by Paddy Mountain to the north and Penns Creek to the south, the railroad put Weikert on the map as a flag stop. It soon had a post office, country store, and, in 1880, a Union church, named Hironimus Church after Andrew Hironimus, who had given the land for it. A school was erected in 1898. Timber was cut from the mountain slopes and, in times of high water, floated down Penns Creek, but it was the railroad that allowed the timber companies to clear the virgin forest until it was gone, eventually collapsing the operation.

Today, with the virgin forest gone and the railroad line abandoned, the towns in the West End live by servicing the surrounding farms. Some towns now have only a few homes, and residents who are not involved in agriculture either travel a distance to their employment or have found a niche for their skills. Once the timber was removed, the railroad was no longer viable. Many workers moved elsewhere. The village of Pardee, four miles west of Glen Iron, was founded by Ario Pardee, who never actually visited the village. He erected a sawmill and worker houses and put a bridge across Penns Creek. Pardee's timbering company failed financially, and its buildings were sold at sheriff's sales or abandoned. Towns like Pardee no longer have commercial

enterprises, but a cluster of houses and a group of permanent residents remain. The West End, over the years, has regained its beauty, and today, the hillsides along Penns Creek attract hunters, campers, and vacationers.

The rural West End of Union County experienced boom-and-bust cycles that depended on the exploitation of its natural resources and advances in transportation. As railroads, horse-and-buggy roads, and automobile highways favored them or passed them by, some towns and villages accommodated; others slowly faded. The history of Mifflinburg and the West End tells the story of a rural America steeped in agriculture and benefiting from the skills and resolve of its people. It is a great unfolding story of innovation and obsolescence, of risk and reward, and of sturdy, determined people who made a life for themselves with courage and drive. In these photographs, we see both the hardship and joy of the people as they lived, worked, and celebrated. This book honors their achievements.

In each of the chapters ahead, photographs show Mifflinburg and the West End progressing east to southwest from Mifflinburg to the towns along Penns Creek: Swengel, Millmont, Laurel Park, Glen Iron, Pardee, and Weikert; then west from Mifflinburg along Route 45 through Hartleton and passing north of Laurelton. The captions give clues and context, but the photographs tell the story. The West End is capitalized not because it is a specific place or town, although it is the west end of Union County. The West End has coherence and character as well as a common historical development that unite it.

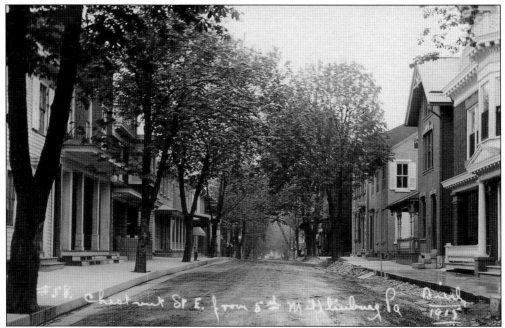

This 1915 view looking east from Fifth Street shows the middle of the 400 block of Chestnut Street. The building with the columns on the left side is the theater, called the Lyric from 1908 to 1925. Two lots east of the theater is the location of the home of Elias Youngman. Rev. J.G. Anspach later occupied it. (UCHS 85.18.11.)

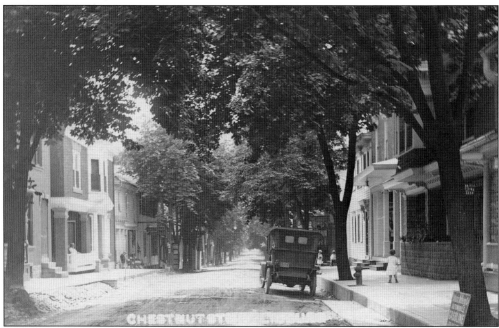

Looking west near the same vantage point as above, the home of Dr. A.H. Hill is to the right of the Lyric Theater, the building with columns. Opposite the Lyric are the homes of attorney John A. Beard, who willed his home to the borough for a community center, and Dr. Oliver Pellman, dentist, who registered the county's first automobile, a one-cylinder Cadillac, in 1904. (UCHS 85.18.9.)

One

LIVING

Once at the frontier of settlement in Central Pennsylvania, brave pioneers to the Buffalo Valley settled in what became Mifflinburg. From the very beginning, entrepreneurs risked what they could, developing businesses and industries that thrived and waned. They expressed their success in large Victorian-style homes. Many dating back to the 1830s, one as early as 1808, and several from the 1860s still exist today. These structures give a sense of historical continuity to the town and hark back to an earlier era, one in which people shared hardships as well as the joys of achievement. While some structures have been razed (the old Mifflinburg High School), others were pulled back from the brink of destruction and have been restored to functionality (the Elias Church).

The rural hinterland is a story of connection. Towns sprang up because the railroad chose to put a whistle stop or station there. As one follows the progress of the railroad westward, through Swengel, Millmont, Laurel Park, Glen Iron, Pardee, and Weikert, one notices that transportation was the key to selling and buying products, to the growth or loss of industry, and to the variety of leisure activities to be enjoyed. By following the railroad into the West End, towns with a station soon had a cluster of houses, a small church, one-room school, perhaps a hotel, and often a general store. The railroad itself, following Penns Creek as well as economic need, spawned pockets of opportunity. After the railroad era played itself out, the automobile determined the lay of the land. The turnpike, current Route 45, brought Hartleton to life, and its turn-offs provided places of respite and relaxation. Laurelton Center put Laurelton on the map as a place of safety and refuge for women, and ultimately men, with mental and physical disabilities who could live with the care they needed.

The Mifflinburg and West End story is one of cycles—of risk and reward, success and failure. Towns thrived and withered, but the people were strong and established a way of life that has served Union County for 200 years.

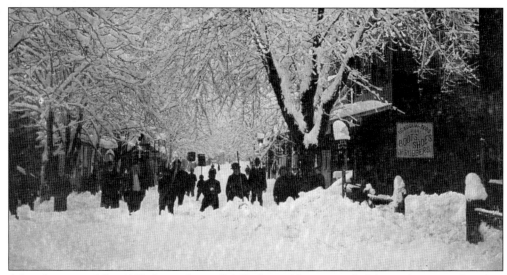

After a large snowfall in 1907, the residents of Mifflinburg add some snowball fun to their snow-shoveling labor on Chestnut Street. The J.E. Bibighaus Store to the right advertises itself as the "Headquarters for Boots, Shoes, and Rubbers." The message on the postcard reads, "Be very sure and come up. Will be disappointed if you don't." Perhaps the friend should bring along a shovel. (UCHS 89.15.9.)

In 1913, Thompson Street was fairly barren of homes except at the corners of Third and Fourth Streets. J.P. Rothermal held an auction of 40 lots on Thompson Street, between Third and Fourth Streets. To bring a crowd, he advertised widely, hired the Yeagerstown Military Band, and chanced off a lot valued at $300. It was estimated that 2,000 spectators attended. (UCHS JD.)

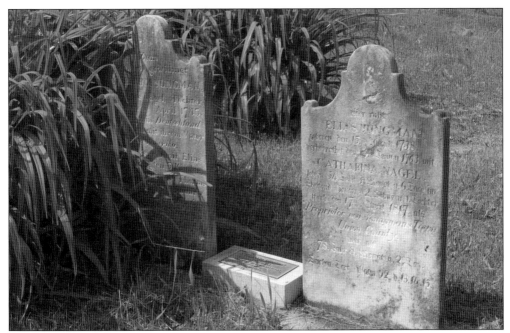

Elias (1738–1817) and Catherine (1745–1822) Youngman founded and developed Youngmanstown, which formed the western, more heavily settled part of Mifflinburg. The couple had two sons and one daughter. The Youngmans are buried near the Elias Church. The epitaphs on their gravestones are in German, reflecting their German origins and the town's early ethnic makeup. (MLH.)

The Grove house, now situated behind 401 Market Street, is one of the earliest frame structures in Mifflinburg, possibly dating to as early as 1808. It stood at 422 Market Street until 1878, when it was moved behind the house for use as a stable. In 1949, it was moved to its present location to save it from demolition. The house has been restored, with the old timbers left exposed. (MLH.)

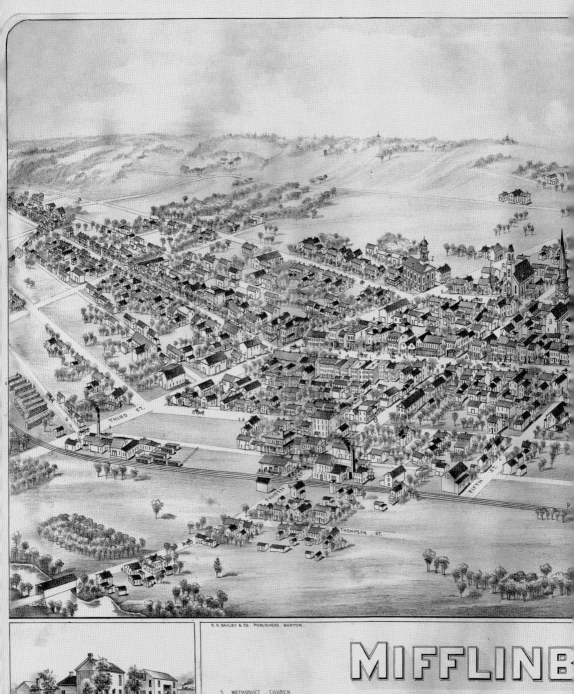

O. H. BAILEY & CO. PUBLISHERS BOSTON.

THIRD ST.

FOURTH

THOMPSON ST.

FIFTH ST.

MIFFLINB

UNION COUNTY, PA.

1884.

1	METHODIST	CHURCH
2	PRESBYTERIAN	"
3	LUTHERAN	"
4	REFORMED	"
5	PRESBYTERIAN	"
6	PUBLIC SCHOOL	

RES. OF JOHN V. RULE.

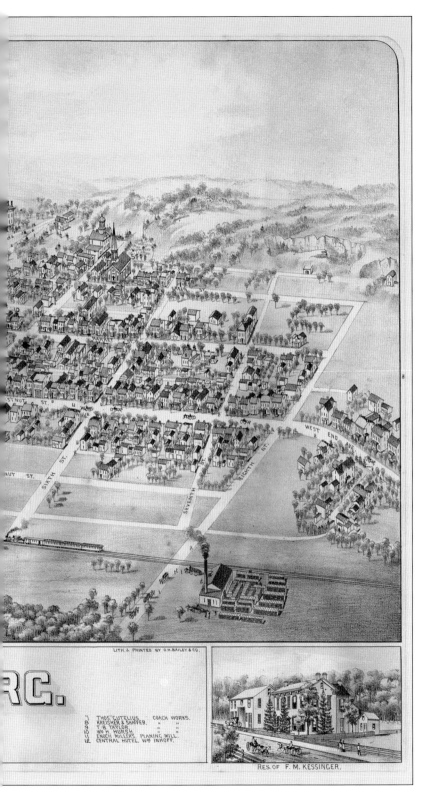

LITH. & PRINTED BY O.H.BAILEY & CO.

RC.

7 THOS. CUTELIUS COACH WORKS.
8 KREISHER & SHAFFER. " "
9 T. B. TAYLOR. " "
10 WM M. HURSH. " "
11 ENOCH MILLER'S. PLANING MILL.
12 CENTRAL HOTEL. WM INHOFF.

RES. OF F. M. KESSINGER.

This 1884 map of Mifflinburg from the perspective of facing south shows the east-to-west streets bending at Third Street, which forms the seam of the merger of Rotestown to the east and the more developed Youngmanstown to the west. The Methodist church stands at the corner of Third and Market Streets, and the Presbyterian Church, later called St. Paul's United Evangelical Church, is seen in the 300 block of Market Street. The First Lutheran Church with its tall tower and the German Reformed Church were erected almost directly across from each other in the 400 block of Market Street. The public school with its cupola stands at the far south of town with the Elias Church and the Presbyterian First Church nearby. The railroad depot stands at North Fourth Street, and Enoch Miller's planing mill is at North Eighth Street near the railroad track. (MBM.)

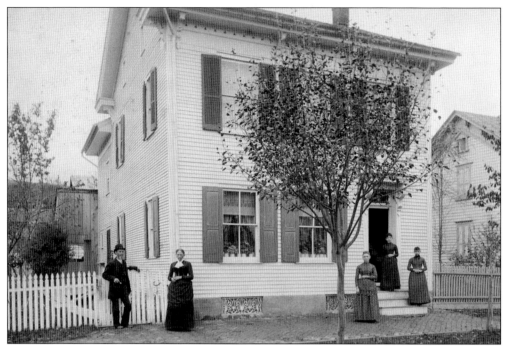

John and Katherine Gutelius stand at their residence, 527 Market Street, about 1895. At the entrance to the home are their daughters Sarah Jane, Ida May, and Lillian Minerva. The Gutelius family ancestors arrived from Lancaster County around 1802. They had 15 children, and according to Charles Snyder, by 1900, more persons in Mifflinburg carried the surname Gutelius than any other. (UCHS 1994.32.45.)

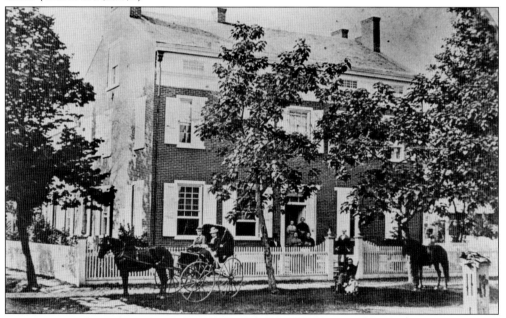

The Henry Gast house at 401 Market Street was built about 1845 by Samuel Noll. Noll used hard pink brick from Philadelphia on the front of the house and marble on the foundation and sills. The sides of the house were built of locally made brick laid on a limestone foundation. (UCHS 89.5.7.84.)

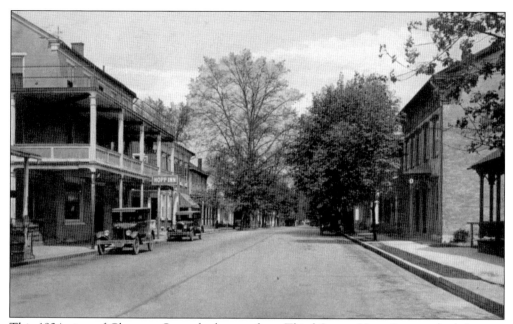

This 1924 view of Chestnut Street looks east from Third Street. Hopp Inn on the left was a forerunner of today's Mifflinburg Hotel & Scarlet D Tavern. Chestnut Street is paved and curbed and sports large two- and three-story buildings, reflecting the successful enterprises of its citizenry. (UCHS 90.21.8.)

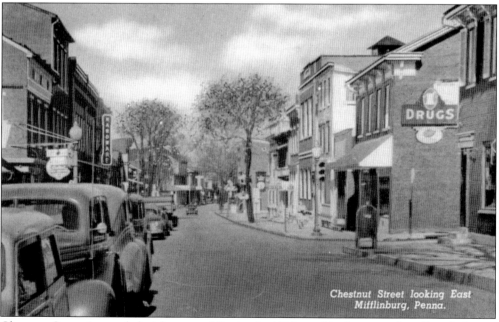

Chestnut Street is crowded with automobiles in the 1930s, and looking east from Fourth Street, one sees its continued development. Even a traffic light has been installed. Reed's Drugstore on the southwest corner was a popular place for ice cream and soda. The drugstore also served as the Greyhound Bus station. (UCHS 2007.23.2.)

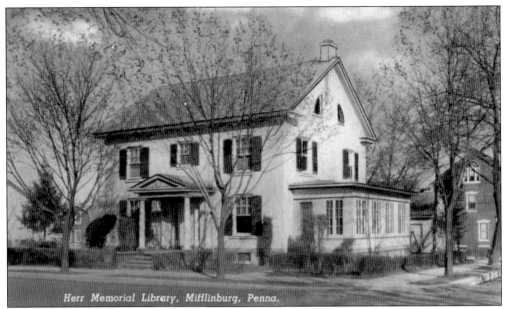

The Herr Memorial Library at 500 Market Street is an independent member of the federated Union County Library System. The Herr sisters Jane, Jessie, and Mabel had the house constructed in 1925. It was built in the Georgian Revival tradition, using yellow brick. Jane, the last surviving sister, willed the house with an endowment to the town to be used as a library. (UCHS 2001.62.11.)

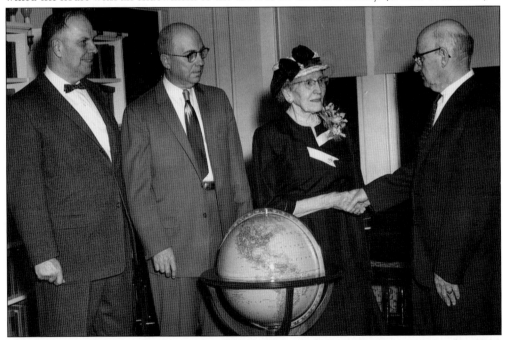

The dedication of the Jane I. and Annetta M. Herr Memorial Library took place in October 1944. Present at the ceremony, from left to right, are board of trustees members Kenneth A. Bidlack, Esq.; O.R. Laney; Myrtle Kurtz, librarian; and Charles Loy Sanders. The library is named for the Herr sisters' paternal grandmother, Jane Irwin Herr, and their mother, Annette M. Young Herr. (Courtesy of David Goehring.)

The pre–Civil War Mifflinburg Lock-up resides behind the former Henry Gast house at 401 Market Street. The structure measures roughly 12 by 15 feet. It stood on Sixth Street just behind the Mifflinburg Academy and present site of the Mifflinburg Buggy Museum Visitors Center until 1972, when it was moved to its present location. The present owner uses its two cells to accommodate overnight house guests. (MLH.)

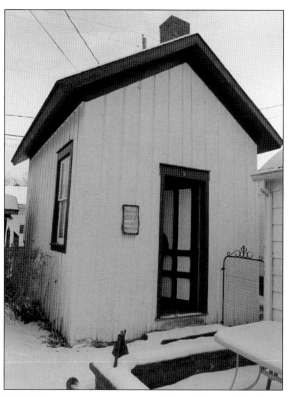

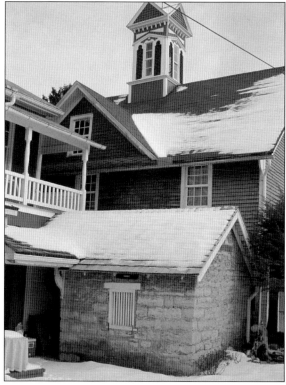

Having built his house in 1845, Henry Gast constructed wood conduits to pipe water from a spring bordering the cemetery and his property. The pipes provided the adjacent springhouse with running water. Seen here under a snowy roof, the springhouse stands beside a coach house on the same property, which was built around 1900 by the Reish family, the second owners of the property. (MLH.)

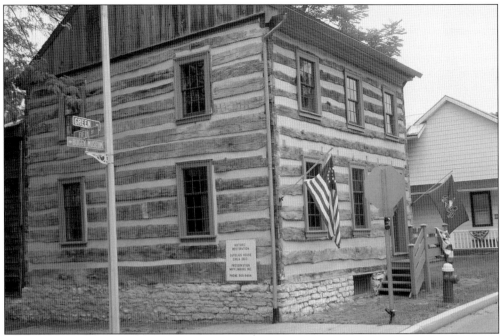

Frederick and Anna Catherine (Bistel) Gutelius built their homestead at the northeast corner of Green and Fifth Streets in 1803. It was a log house to which siding was also applied. The house is now owned by Preservation Mifflinburg, Inc. Frederick was a blacksmith by trade and studied surveying. He was elected commissioner of the new Union County in 1813. (MLH.)

Designed by architect Lewis Palmer of Lewisburg, the residence of William B. Young at 333 Chestnut Street was built in 1857. It provided ample space for Young's family of 13 children. Young operated a store and built the Young Hotel, later called the Buffalo Valley Inn. His son Harry sold the home to the Borough of Mifflinburg in 1930. The structure has recently been threatened by the wrecking ball. (MLH.)

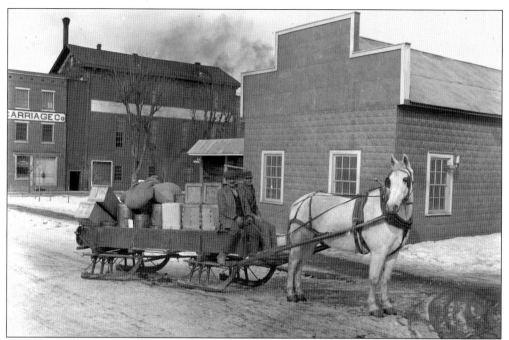

Clark Lance, seated left, used a bobsled to convey goods from the railroad station. The three-story Hopp Carriage Company in the background stood at the corner of Fourth and Walnut Streets. The building with the stripe above the second floor was Sankey Hall, pictured here about 1915. The auditorium and stage were on the second floor, where traveling companies as well as local bands and actors performed. (UCHS JD.)

Romig Square, also called "Kittyville," was named for Katherine Romig, an early real estate developer. Having heard the rumor that a large factory was to be built at the corner of Eighth and Walnut Streets, Kitty began building houses on both sides of Walnut Street between Sixth and Eighth Streets, just a block from the Mifflinburg Buggy Company. This postcard is dated 1909. (UCHS 79.475.22.)

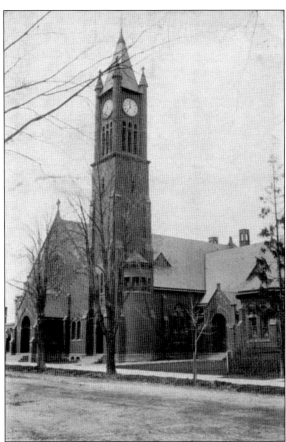

The First Evangelical Lutheran Church at 404 Market Street was constructed between 1898 and 1901 on the site of an earlier, smaller Lutheran church dating from 1858. J.A. Dempwolf was the architect and Enoch Miller the builder. Pictured here in 1909, the bell tower houses the community clock, placed there by the borough. (UCHS 94.95.)

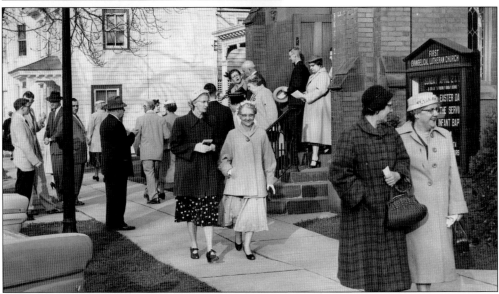

On this Easter Sunday in the 1960s, the congregation leaves the First Evangelical Lutheran Church. Fashion required Easter hats, but the weather seems to have been cool. The parking lot to the left of the church building did not yet exist. (MBM SC.)

An early Methodist two-story brick structure was built in 1856. In 1893, the congregation razed this building, cleaned the bricks, and used them for the wall on the east side of a new building. The present 1893 Gothic structure was designed and built by Enoch Miller. A Moeller pipe organ, assisted by a gift from Andrew Carnegie, was installed in 1906. (UCHS 83.38.6.)

This 1914 photograph of the German Reformed Church shows its exceptionally tall steeple, which was destroyed by lightning in 1916. The church was erected in 1857, following the separation of the Lutheran and Reformed congregations, which had until then shared the older Elias Church. (UCHS JD.)

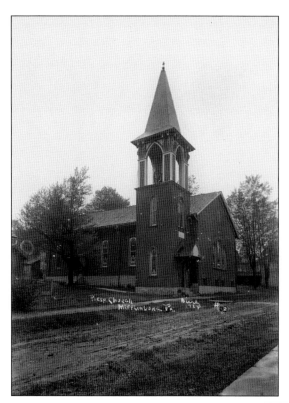

A Presbyterian congregation was formed in Mifflinburg in 1818–1819 and was served by supply ministers, including Rev. David Kirkpatrick, who was also the principal of the Mifflinburg Academy. In 1846, the congregation built a brick church on Green Street. In 1881, it collapsed under the weight of a heavy snow and was rebuilt the same year. This photograph is dated 1914. (UCHS JD.)

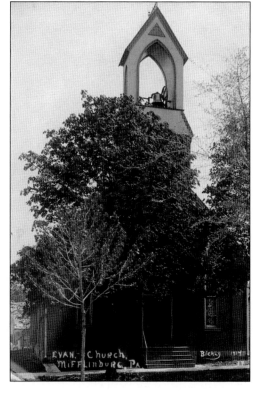

The Buffalo Presbyterian Church, erected on Market Street in 1881, ceased to be used after the Presbyterian congregations merged in 1901. The church was then sold to the United Evangelical congregation and dedicated in 1902 as St. Paul's United Evangelical Church. William A. Heiss, the buggy-maker, was the first Sunday school superintendent, and his wife, Anna Heiss, was the first Sunday school teacher and organist. (UCHS 85.6.4.)

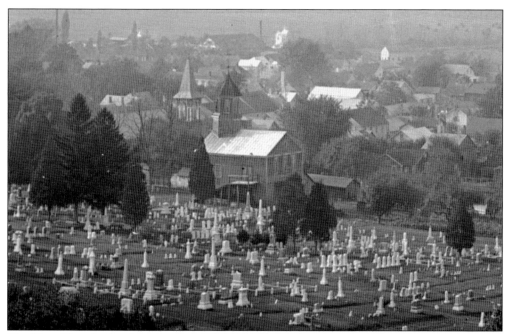

The Elias Church, found in the center of this 1915 photograph, is the oldest remaining structure in Union County to have been used as a church. Erected in 1806, the German Reformed and Lutheran congregations worshipped there jointly until 1857. The building's *Liegender Stuhl* (lying chair) roof truss is believed to be the only surviving example of this German roof-framing system. The belfry was removed around 1920. (UCHS JD.)

At the corner of Fifth and Green Streets, the German School was erected before 1813 on land donated by the Youngmans specifically for the purpose of operating a German school. For a few months in 1814–1815, the building served as the county courthouse while one was being built in New Berlin, the county seat of the newly formed Union County. (MBM SC.)

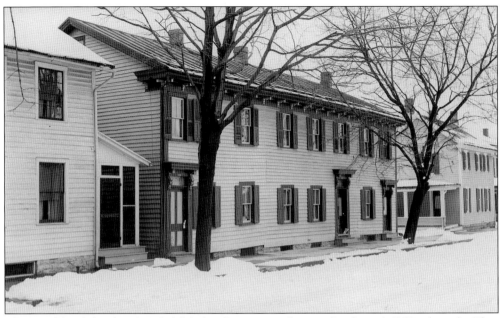

The Franklin School at 314–318 Market Street served as a school until 1857, when the Elias Church building became the sole public school in Mifflinburg. Later, the school became part of three contiguous residences, owned for a time by Dr. D.H. Miller as a rental property. Seen here in the 1940s, the Mifflinburg Bank & Trust Company razed the building to make room for a parking lot. (MBM SC.)

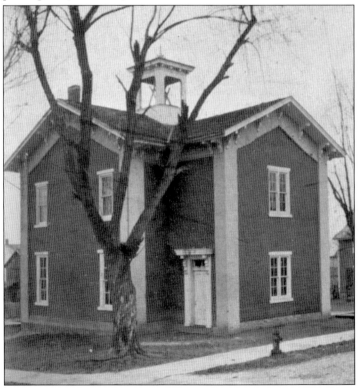

The Mifflinburg Academy, later also called the Grammar School, was built at Green and Sixth Streets. Seen here in the 1920s, it was chartered in 1831 for secondary students before the coming of public schools. It was used as a public school at various times from 1870 through 1955. After World War II, it was needed to accommodate large grade school classes. The building was razed in 1978. (UCHS 82.1.13.)

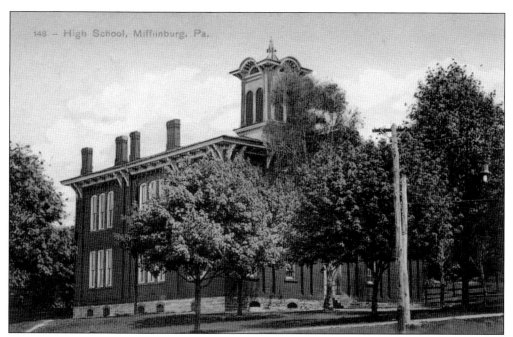

Surrounded by a grove of 66 Norway maple trees planted in 1889, Mifflinburg's first high school was erected in 1876 and stood at the intersection of Third and Fourth Streets at Maple Street. Graduating diplomas were first awarded in 1889. In 1953, it became an elementary school for the first eight grades until 1980. It was razed in 1982. (UCHS 83.37.1.)

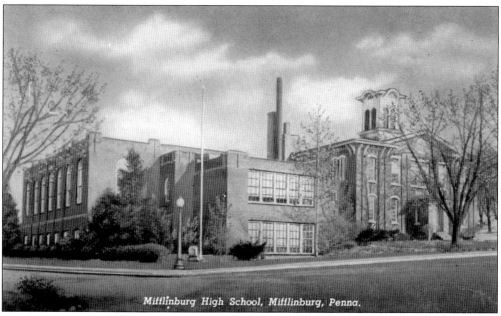

Mifflinburg High School, Mifflinburg, Penna.

The Mifflinburg High School, erected in 1876, built an extensive addition in 1924. This addition included a new auditorium, a gymnasium, and elementary grade rooms. The original auditorium was divided into four classrooms. (UCHS 82.2.79.)

27

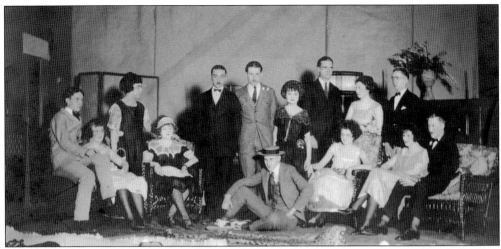

The play *Am I Intruding*, a comedy based on a mystery plot, was performed in 1923 by the Mifflinburg High School class of 1924. The actors pictured here, from left to right, are Lee Frances Lybarger Jr., Mary Gutelius, Jane Swartz, Hazel Strickler, Colfax Maize, Charles Lontz, Miles Huntingdon (on floor), Helen Ruhl, William Lybarger (director), Elizabeth Stahl (sitting), Hattie Fertig, William Royer, Eleanor Hopp, and Alvin (Bony) Barker. (MBM SC.)

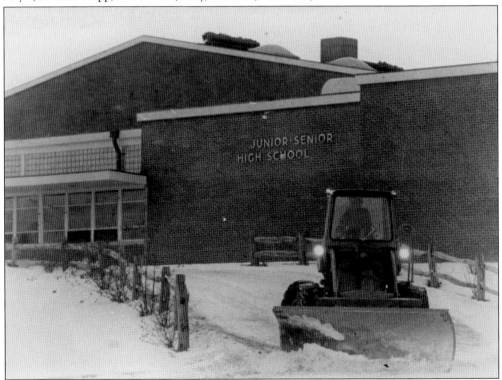

The Western Area Joint School District was organized in 1950. It provided for a new junior and senior high school, which opened, in part, in 1952, a one-story building with extensive grounds on land that had been the Irwin farm. The school system subsequently became the Mifflinburg Area School District. Perhaps a snow day was in the offing, which students have always fervently hoped for. (MBM.)

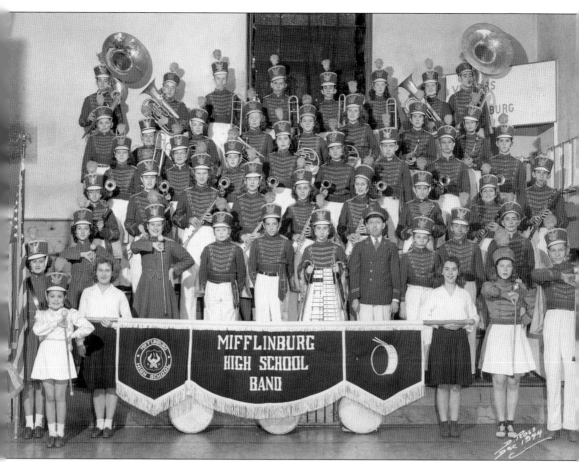

The Mifflinburg High School Band poses in new uniforms in 1944. Bandleader Cecil D. Shirk is in the second row, fourth from the right. From left to right, the band members are (first row) Barbara Kemble, Roberta Reidell, Ruth Wendel, Jeanne Marie Grove, Dorothy Diehl, and Earl Ruhl; (second row) Betty Keister, Winifred Kemble, Thomas McQueen, William Young, Jeanne Throssel, Mr. Shirk, George Sterling, Jacob Bingman, and William Brungard; (third row) Nancy Katherman, Dorothy Ann Finkel, Joyce Feaster, Charlotte Hackenburg, Greta Klingman, Frances Grove, Harold Klose, Betty Chambers, and John Young; (fourth row) Barbara Frederick, Patricia Schrader, John Stoudt, Edna Grove, Ruth Wehr, Thomas Miller, Donald Hoy, and John Boyer; (fifth row) Clair Mitch, Neil Kemble, Evelyn Kelly, Grace Musser, Marie Kerstetter, Elizabeth Laney, Sara Ilgen, and Kay Katherman; (sixth row) Deane Shively, William Musser, Donald Haney, Blaine Purnell, Jack Throssel, Gean Laney, Louise Chambers, and Franklin Dale; band member John Chambers is absent. With the revival of football in 1946, band activities expanded to include performances at home and away football games. (UCHS 93.13.1.)

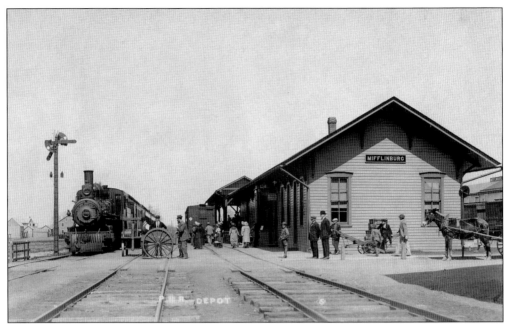

Located at North Fourth and Railroad Streets, the Mifflinburg railroad station, seen here in 1914, is similar in appearance to many stations on the Pennsylvania Railroad. The original structure burned in 1880. A stop on the Lewisburg & Tyrone Railroad, later called the Pennsylvania Railroad, which had reached Mifflinburg in 1871, the station handled both passengers and freight. (Courtesy of Billy Mattern.)

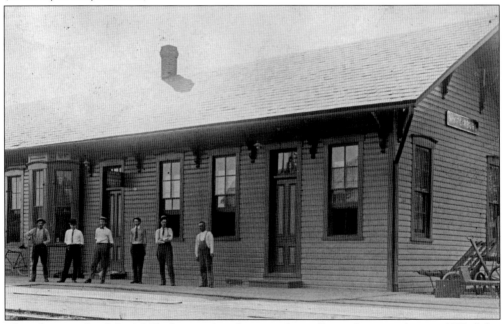

This photograph of the Mifflinburg railroad station from the tracks was taken in 1919. John Alexander Dersham, an accountant for the Mifflinburg railroad station, stands second from the right. The other men are unidentified but are also employees. They pose with their satchels stashed near the station door. (Courtesy of John Dersham.)

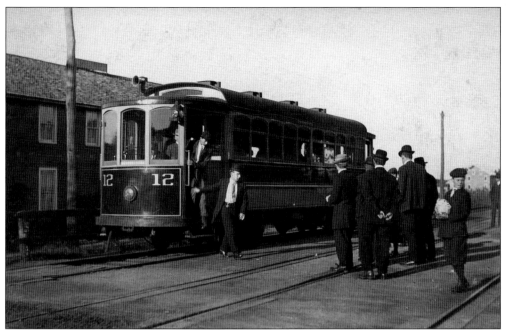

The Lewisburg & Tyrone Railroad withdrew its local steam passenger trains to Montandon and Mifflinburg in 1912. It then permitted the Lewisburg & Milton Trolley Company to use storage battery cars on this run. From Watsontown to Lewisburg, the trolley was under wire. From Lewisburg to Mifflinburg, it ran on storage batteries. The same principle is used today in hybrid cars. (Courtesy of Billy Mattern.)

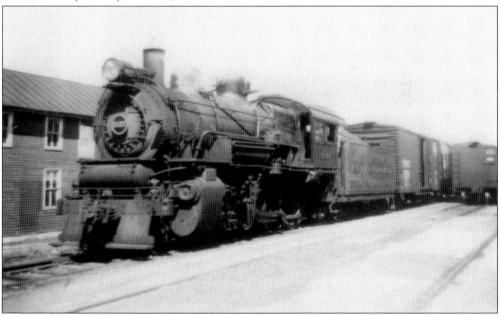

The Pennsylvania Railroad 3127, H-10 locomotive arrives in Mifflinburg from Northumberland on March 30, 1945, with local freight. The train will continue west to Glen Iron after servicing Mifflinburg businesses. Behind the engine is the Kurtz and Sons Overall Factory. (Courtesy of David Goehring.)

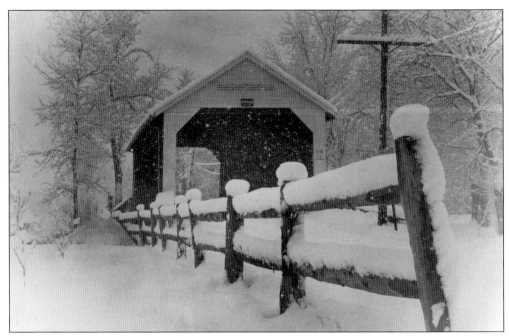

The one-span covered Hassenplug Bridge was built in 1825 across Buffalo Creek. Squire Whipple, a pioneer of modern bridge design, reinforced the original Burr truss construction in 1840. In 1959, the wooden floor was replaced by a steel grill, the foundation restored, and the woodwork repaired. (UCHS 89.5.8.25.)

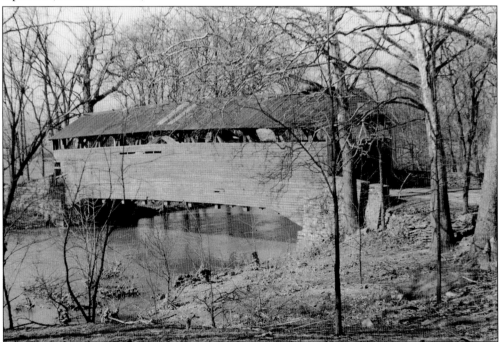

The Hassenplug Bridge is 80 feet long. In this side view, one can see the Burr truss just below the roof. The Hassenplug Bridge is thought to be the oldest remaining covered bridge in the county. It is located on North Fourth Street in the borough of Mifflinburg. (UCHS 89.5.8.22.)

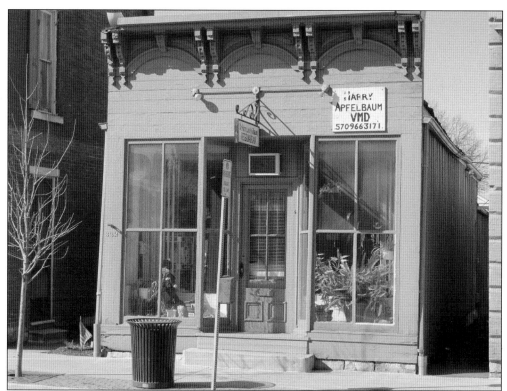

The one-story Victorian building at 332 Chestnut Street served as Mifflinburg's post office and Dr. Steadman's medical office from 1868 to 1883. Steadman was named postmaster, possibly due to his limited practice. Steadman suffered a disability from his service during the Civil War. When he died 10 years later, his wife, Julia, was named to succeed him. The building is presently the office of Dr. Harry Lee Apfelbaum, veterinarian. (MLH.)

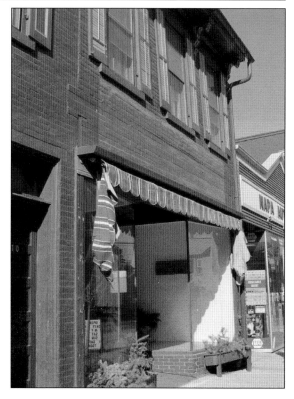

This building at 408 Chestnut Street served as the Koons Hardware and Electric Company, a business owned by Arthur Koons and his son William. After the hardware business was discontinued, Arthur's daughter, Mary Koons, moved her dress shop to that location, celebrating the grand opening on April 9–11, 1981. Her merchandise line later included handmade Amish and Mennonite quilts, for which the shop became well known. (MLH.)

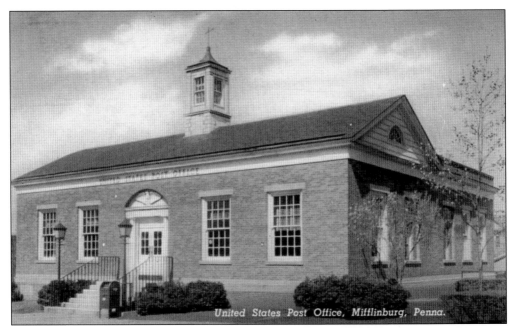

The Mifflinburg Post Office was constructed in 1940–1941, a project designed as part of the New Deal. The postmaster was Samuel B. Miller. The interior is adorned with four murals by K.R. Bennett with scenes of people and activities important to Mifflinburg. The four scenes thematically depict hunting, men at work, women at work, and hospitality. (UCHS 88.30.2.)

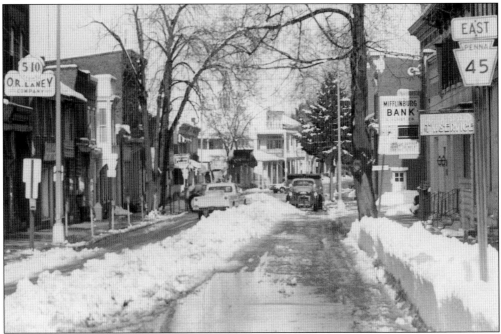

Chestnut Street has been mostly cleared after a 1967 snowfall. Looking east toward the 300 block, the O.R. Laney Five-and-Dime Store stands at left, across from the Mifflinburg Bank. Ortha R. Laney opened the store in 1936 in the former Gast Dry Goods Store building. In 1976, Laney sold the store to Donald and Carolyn Haag, who ran the business for another 12 years. (MBM SC.)

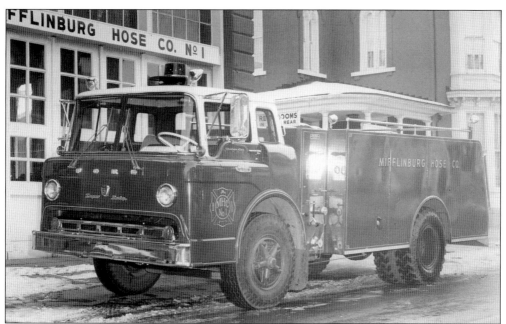

Volunteers formed the Mifflinburg Hose Company in 1898 to provide fire protection for the community. In 1928, the fire company moved to the 300 block of Chestnut Street into an old bank building erected in 1872, shown here in 1966. In 1976, the company needed additional space, so it demolished the two-story Mifflinburg Hose Company Building and constructed a new building to accommodate four truck lanes. (MBM SC.)

The Farmers' Bank at 407 Chestnut Street was built in 1889 by Enoch Miller (1835–1923), who designed and constructed many Mifflinburg buildings still standing. The Farmers' Bank occupied the building until 1908, when it moved across the street. It remained there until 1930, when it merged with Mifflinburg Bank & Trust Company. The building has since housed a number of small businesses. (MLH.)

The Mifflinburg Bank moved to 343 Chestnut Street in 1925, at which time the *Mifflinburg Telegraph* praised the modern building as "the great forward step." In the same year, the bank was granted trust powers and became the Mifflinburg Bank & Trust Company. Both the Farmers' Bank, in 1930, and the Laurelton State Bank, in 1941, merged with the Mifflinburg Bank & Trust Company. The bank vacated this building in 1998. (MLH.)

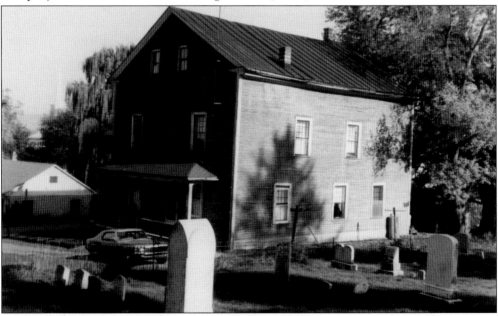

The Elias Church, erected in 1806, was used as a church until 1857. Since then, the building has been a school, a barn, a repository for the John Gutelius buggy works, and a double-family dwelling, as seen in this 1978 photograph. The Mifflinburg Heritage and Revitalization Association restored the building, with plans for it to be used for performing arts and special events. (UCHS 89.5.2.8.)

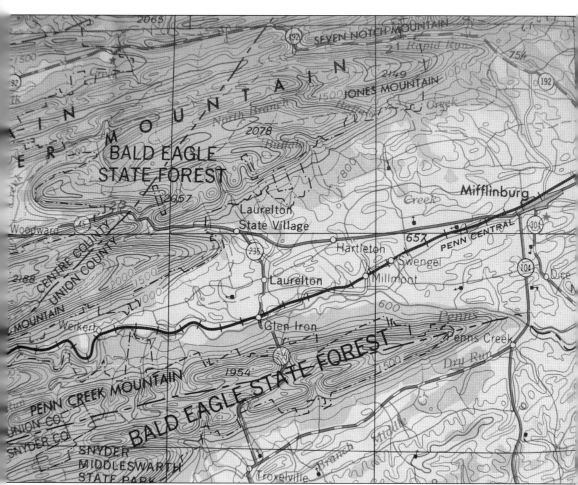

This map shows the path of the Pennsylvania Central Railroad, earlier the Lewisburg & Tyrone Railroad and before that the Lewisburg, Centre & Spruce Creek Railroad. The railroad leaves Mifflinburg toward the southwest to follow the course of Penns Creek and leads ultimately west of Cherry Run into Centre County. The railroad determined much of the early history of the Union County West End. Those towns awarded a station or siding—Swengel, Millmont, Glen Iron, and Weikert—developed earlier and enjoyed greater employment opportunities. Other whistle stops grew, such as Laurel Park and Pardee, as industries needed them. The old turnpike (Route 45) through Hartleton became important later with the coming of the automobile. (US Geological Survey, 1969.)

Although settlers had come to the area earlier, Swengel was born in 1874 when the Lewisburg, Centre & Spruce Creek Railroad Company bought the right-of-way through Lewis Township. John Swengel laid out the town, and a post office was established in 1875. The Swengel Post Office, pictured here in 2011, was in a private residence, as post offices in small rural towns often were. (MLH.)

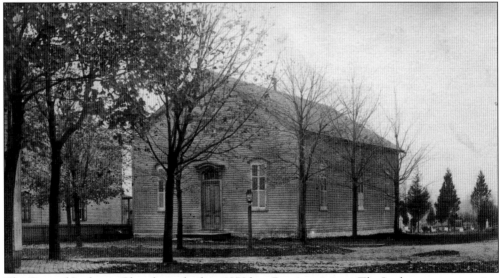

The Swengel Lutheran Church was built in 1878 by a Baptist minister. The Lutheran congregation organized in 1886. This postcard, dated 1907, shows the church without its bell tower, but the bell from that tower is one of the four bells at Christ's United Lutheran Church on Route 45. The Swengel church building has been converted to a private residence. (UCHS 94.7.3.)

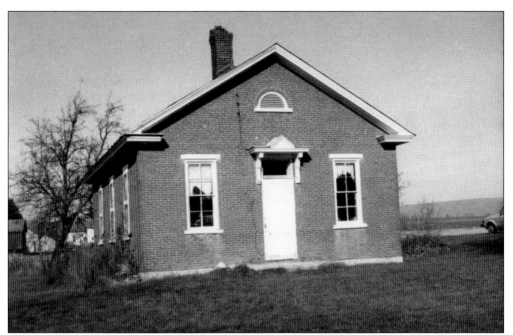

The Swengel schoolhouse, now home to C&S Woodworking, was constructed in 1889. This schoolhouse replaced a previous brick school built prior to 1837. The school closed in the 1950s when schools in the West End were consolidated. Many of the 70 one-room schoolhouses that dotted the landscape of Union County were destroyed or repurposed. By 1953, only 13 remained. (MBM SC.)

Pictured here in the early 1950s, the Lewis Township High School building was erected in 1899. It became a high school in 1902. When Pike Elementary School was destroyed by fire in 1929, the grade school classes were housed on the east side of the building. After the Western Area Joint School District was organized, the Lewis Township High school closed in 1953. (Courtesy of Linn Mensch.)

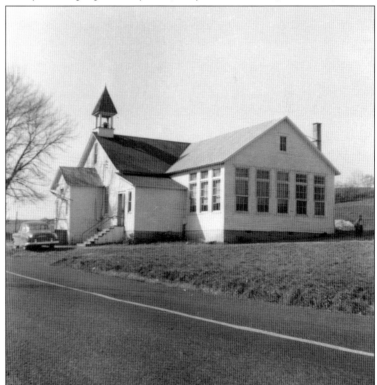

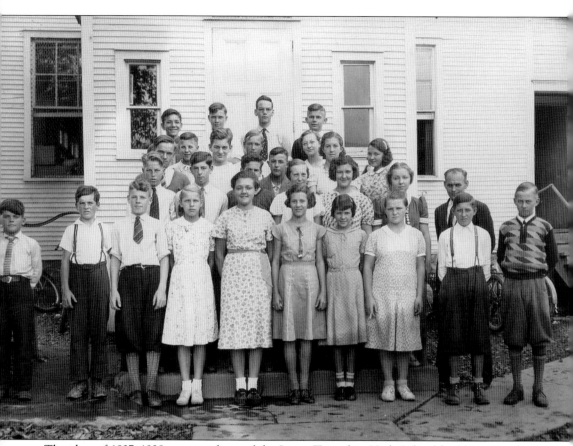

The class of 1937–1938 poses in front of the Lewis Township High School building. Members of the class are, from left to right, (first row) Donald Shively, William Shively, Charles Shipton, Mary Louise Herendeen Knauss, Hertha Shively Wehr, Betty Erdley Watters, Mildred Bingaman Eisenhuth, unidentified, Harold Wenrick Jr., and Neil Boop; (second row) unidentified, Laird Shirk, Tobias Catherman Jr., Donald Arney, Cloycie Hassinger Spieglemeyer, Dorothy Blackford Evans, Nora Boop, and teacher Fred Showalter; (third row) Clarence Boop Jr., William Wenrick, Robert Shirk, Ernest Boney, Marie Yarger McCain, Leona Shirk Hackenberg, and Kathryn Irwin Fritz; (fourth row) Charles Catherman, Warren Wirth, Franklin Knauss, and Ralph Elwood Dreese. (UCHS 2001.61.2.)

The village of Millmont was founded in 1874 by Jacob E. Royer. The Lewisburg & Tyrone Railroad erected a station at the site. This view of Penn Street looks west from Millmont Road. At the far left stands the two-story frame Ruhl and Watson Box Factory, which was destroyed by fire in 1912 and subsequently replaced by a one-story brick building. (UCHS 97.1.19.)

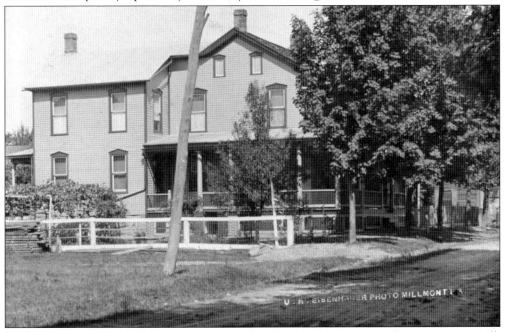

Jacob Royer owned a brick factory, which produced bricks for the railroad station, a gristmill, church, schoolhouse, and several dwellings. Photographer Urs H. Eisenhauer shows off one residence. The message on the reverse side of this 1909 postcard reads, "Mr. Eisenhauer took our house the other day, and you shall have one. When you come to us once, you will not miss the place." (UCHS 90.21.10.)

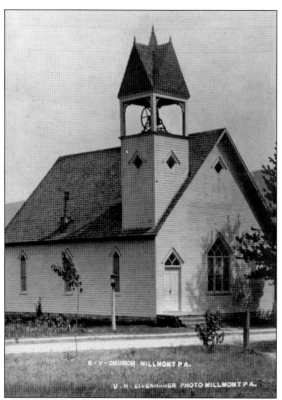

The Millmont United Evangelical Church, seen here in 1910, was built around 1897 on property once owned by J. Thompson Baker. During its history, it was affiliated with a number of different circuits. Around 1963, the church affiliated with the United Methodist Church and remains with the conference at the present time. (UCHS 88.21.4.)

The J. George Royer home stands to the right of the building Royer used as a printing shop and jewelry store. He sold the business to Ralph "Ernest" Ruhl, who was also postmaster from 1921 until 1934. The business building then also housed the Millmont Post Office. The photograph was taken in the 1920s. (Courtesy of Tony Shively.)

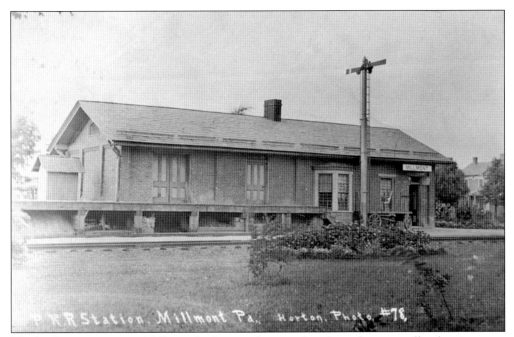

The brick train station in Millmont had many photographs taken of it, especially when its peony beds were in bloom, as pictured here in 1909. Small towns and villages across the valley vied with each other to obtain a railroad station. Millmont was awarded its station, built in 1874. The rail line did not veer from following Penns Creek. (Courtesy of Ronald Nornhold.)

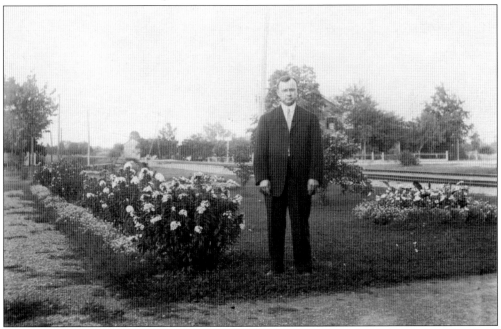

Samuel Sauers, station agent at the Millmont railroad station, is seen here about 1913. The peony beds seem to have been a source of local pride. West End towns with stations grew to provide services and accommodations to workers in the local timbering and mining industries, which used the railroad for the transportation of their products. (UCHS 88.21.2.)

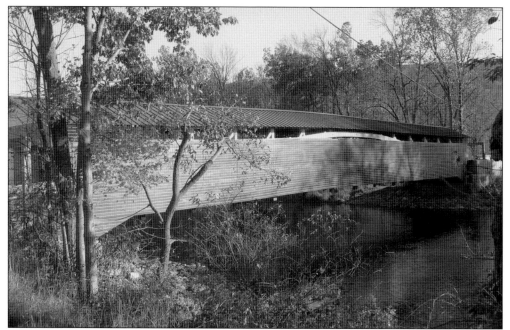

The Millmont Red Bridge, erected in 1857, is 157 feet long, the longest covered bridge in Union County. The plaque affixed to the bridge reads, in part, that the bridge was "made from white pine logs which were cut in the forests upstream and floated to the site. Here, they were sawed and hewed by hand . . . by local workers and framed into the present structure." (MLH.)

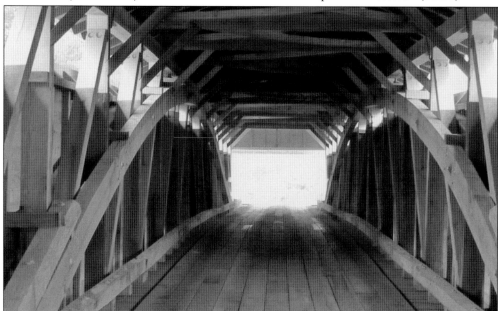

The bridge was refurbished again in 2010. The Burr truss is clearly visible. In June 2006, the *Millmont Times* reported, "In 1804, Theodore Burr patented a design for building covered bridges. Known as the 'Burr Truss' method, the system became the most-used design in building covered bridges in Pennsylvania. His truss method allowed builders to make long bridge spans with great strength." (MLH.)

Because the railroad did not go through Laurelton, it provided a whistle stop for Laurelton farther south along Penns Creek. First called Laurelton Station, then renamed Rutherton, and finally called Laurel Park, the immediate area grew like other places favored by the railroad. Samuel Weidensaul built the Cash Store Company about 1870. Weidensaul enticed the railroad by offering land for a station. (Courtesy of Ronald Nornhold.)

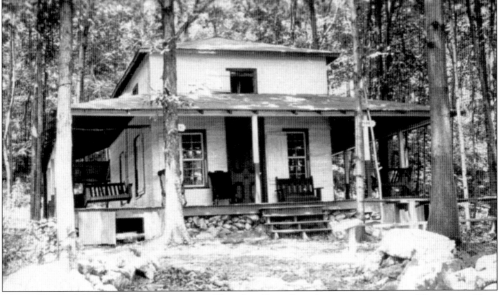

The village of Pardee grew in support of local mill and timbering operations. The post office, located in a company store, operated from 1888 to 1902. Robert and Hattie Tharp ran one of the four stores in Pardee. Seen here around 1920, the store was called the Beer Garden. It was a nightspot for the men stationed at the Weikert Civilian Conservation Corps (CCC) Camp. (Courtesy of Ronald Nornhold.)

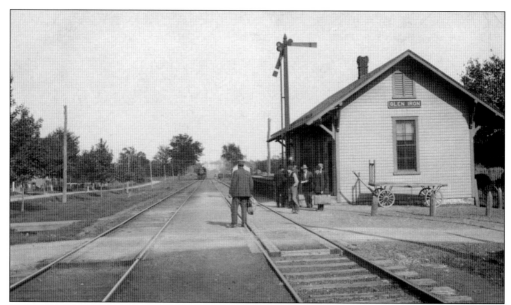

Passengers await the arrival of the westbound train at the Glen Iron railroad station in 1912. The tracks reached Glen Iron in 1873, spurred on by iron mines in the area and the timber industry. The area was also known for summer recreation. One visitor wrote, "Home was never like this out in the little log cabin, but having a dandy time." (Courtesy of Ronald Nornhold.)

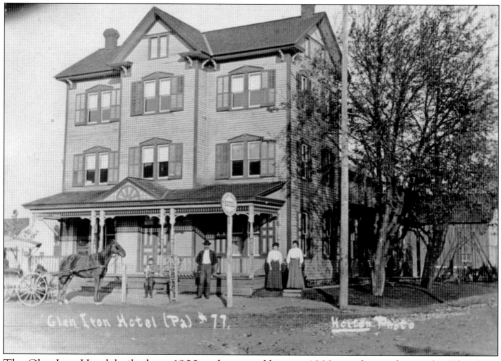

The Glen Iron Hotel, built about 1900 and pictured here in 1908, was located near the Glen Iron railroad station. Frank and Anna Church owned the hotel. After Frank died, Anna managed the business, and Sam Dunlop was the bartender. Sam stands in the center of the photograph; Anna and her niece Alice are to the right. (Courtesy of Ronald Nornhold.)

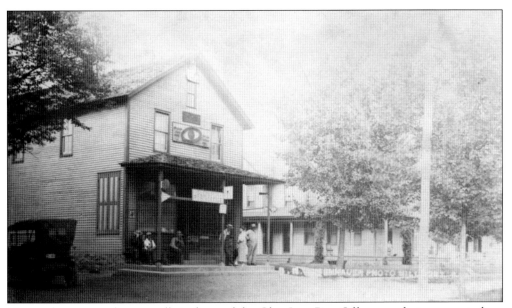

Men and a woman shopper talk in front of the Glen Iron Post Office on what appears to be a warm summer day around 1914. The post office, located in a general store advertising women's shoes on the sign between the upper two windows, became a center of social activity and a source of local news. (Courtesy of Ronald Nornhold.)

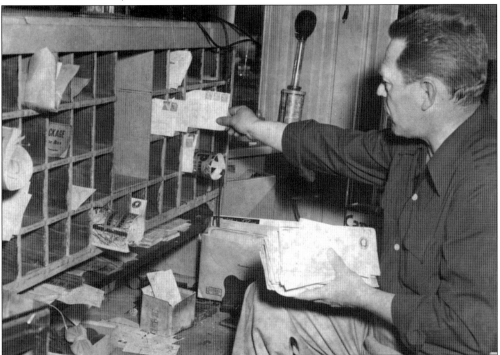

Postmaster Ezra Sassaman works on the last day of business at the Glen Iron Post Office. Sassaman was appointed on April 30, 1946. He was also the first fire chief of the West End Fire Company and a storekeeper. As the railroad and the timber industry had long closed down, the town lost population, and the post office, which closed around 1956, was no longer viable. (UCHS 2005.27.)

The village of Weikert, shown here in 1930, lies nestled in the landscape where the valley becomes increasingly narrow. The area west from here is commonly called the "Tight End" as Paddy Mountain to the north and White Mountain to the south converge. Weikert is named for George Weiker(t) and his brother Jacob, who settled the area briefly before 1810, leaving only the name behind. (UCHS 97.1.4.)

Built in 1880–1881 on land donated by Andrew Hironimus and the brothers Jacob and Jonas Barnett, the Hironimus Union Church stands one mile east of Weikert. The entry vestibule and belfry were added in 1948. The church at one time served the lumbering region and drew much of its membership from the people in the industry. The photograph, taken during a tour, dates from 1964. (UCHS.)

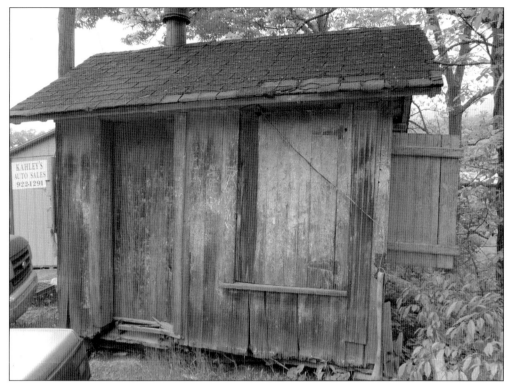

On its way west, the railroad awarded Weikert a whistle stop, and after the railroad finally reached Weikert about 1876, the town grew to include a store, post office, and a cluster of houses. The Weikert railroad station building still exists, seen here on the property of Kahley's Auto Sales. The tiny cabin probably had a wood-burning stove, a chair, and little else. (MLH.)

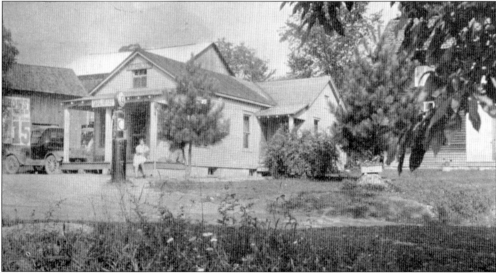

In 1923, Asa R. Sholter became the Weikert postmaster and served in that capacity until 1957. During these years, the post office, seen here around 1931, was located in the Sholter General Store, a popular local gathering place. Gene Kahley later bought the property from the Sholters and built a new post office building, attaching it to the former Sholter Store. (Courtesy of Ronald Nornhold.)

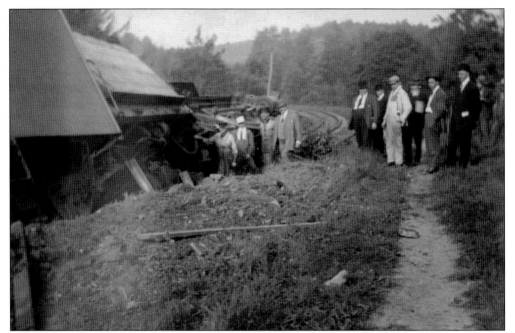

Not everything went as planned. On November 6, 1911, the Lewisburg & Tyrone Railroad experienced a wreck near Lindale, a flag stop west of Weikert. Mrs. Libby wrote to her son in Michigan, "Here is a picture of the wreck Warren E. and Ammon S. are on." The note on the front reads, "Dad/Hoover's train on L[ewisburg] & T[yrone]." (UCHS 94.27.16.)

From the late 1780s until around 1850, merchants along Penns Creek shipped produce to Selinsgrove on rafts, called arks, when the water ran high. The arks were made of white pine, and those on Penns Creek measured from 30 to 40 feet long and 16 feet wide. Butter Rock, the large boulder on the left, gained its name when an ark laden with butter crashed into it. (MLH.)

Col. Thomas Hartley, an officer in the Revolutionary War, laid out what was then called Hartleytown and sold his first deed in 1799. In 1858, the town was incorporated and named Hartleton. Notorious throughout the valley in modern times for having a speed trap, Hartleton cautioned drivers to monitor their speed closely. Also monitoring it was Donald Zerbe, chief of police. (UCHS 92.9.89.31.)

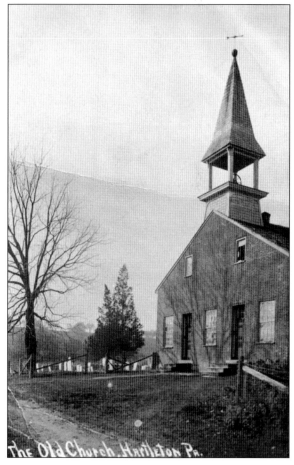

The Union church in Hartleton, shown here about 1907, was built in 1841 for the use of any congregation. The Hartleton Presbyterian Church used the sanctuary until 1885, when the congregation built a church of its own. Donald Hayes restored the interior and exterior in the mid-1970s and left a bequest for its upkeep. It is now owned by the borough. (UCHS 94.6.1.)

The hotel in Hartleton, called Hartley House, was located between the Lutheran and Presbyterian churches. According to Eleanor Hoy, traveling salesmen on their way to Centre County and parents on their way to visit Penn State students often spent the night or enjoyed a meal at the Hartley House. It was eventually turned into a nursing home, operating until 1971. (UCHS 92.9.89.32.)

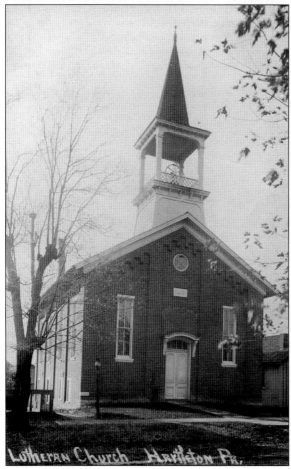

The Hartleton Lutheran Church was built in 1875. It is believed to have been one of Enoch Miller's earlier structures. In response to the drive for funds, at its dedication in June 1876, the sum of $1,600 was raised, canceling the debt. The building, located just west of 501 Main Street, was demolished in the late 1960s following the merger of Lutheran congregations. (UCHS 88.6.5.)

Christ's United Lutheran Church housed four merged Lutheran congregations in 1963. Represented by their bells, the four churches are Laurelton Evangelical Church, built in 1876 and now a private home; Hartleton Lutheran Church, built in 1875 and razed after the merger; St. Peters Lutheran Church (Ray's Church), built in 1883 and now privately owned; and Swengel Lutheran Church, built 1878 and also now a private home. (MLH.)

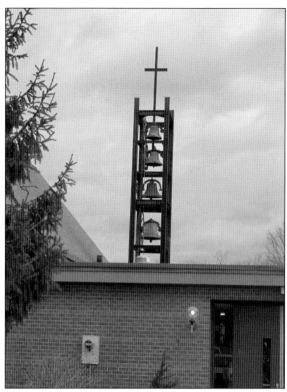

Members of Christ's United Lutheran Church, also popularly known as the Four Bells Church, are pictured along with residents from surrounding communities enjoying a chicken potpie dinner. Ham and beef potpies are also available. This semi-annual dinner, prepared by volunteers, raises funds for the church and provides a great evening of fellowship. (MLH.)

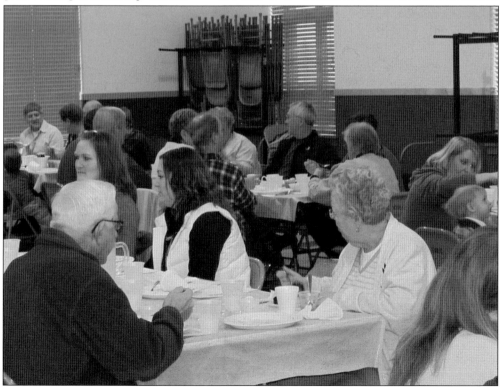

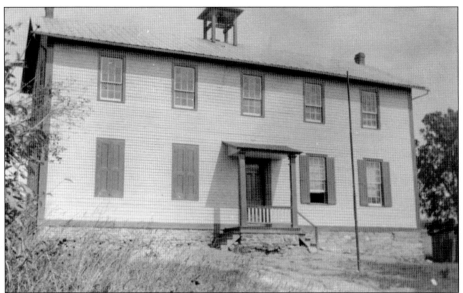

Hartleton School was built in 1862. Originally a two-room school building, a second story was added later. The building closed in 1953 and is no longer standing. Below, Miss Violet Gemberling's first-grade class stands in front of the Hartleton School in 1935. Pictured are, from left to right, (first row) Nanny Diehl, Melvin Diehl, June Printzenhoff, Charles VonNeida Jr., Myrtle Ruhl Shirk, Frances Jean Mitchell Shirk, unidentified, Olive Printzenhoff, Sam Diehl, Warren Sheesley, Helen Bingaman, Pauline Bowersox Shively, and Grace Sheesley Benfer; (second row) unidentified, Mary Jo Smith, June Zettle, Dorothy Printzenhoff, Helen VonNeida Susan, unidentified, Miriam Sheesley VonNeida, and Betty Wilson; (third row) Fred Long, Frank Long, Richard Sheesley, Frank Sheesley, Charles Sheesley, John VonNeida, Harry VonNeida, Jack Shirk, Richard Diehl, Frank Printzenhoff, Lawrence Korman, and Bruce Feese. Miss Gemberling is standing in the doorway. (MBM SC; Courtesy of Tony Shively.)

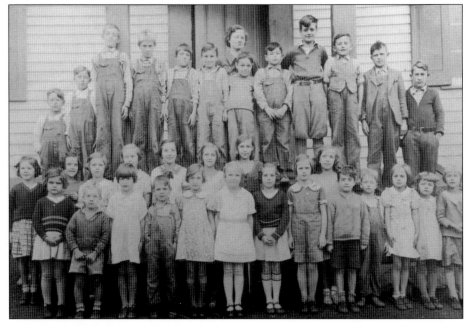

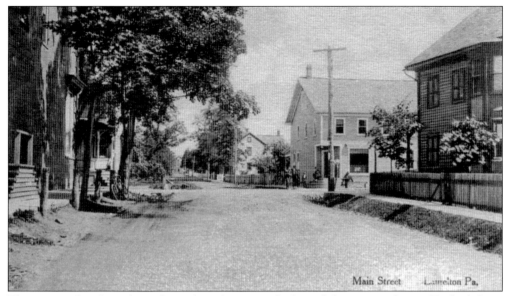

The crossroads at Laurelton, shown here facing north, formed the center of town. To the left are the steps leading up to the porch of the Laurelton State Bank, which merged with the Mifflinburg Bank in 1941. The large building second from the right was Dr. Glover's drugstore and office. At the far right stands the West End Hotel, destroyed by fire in 1922, and the site of the current post office. (UCHS 92.9.89.18.)

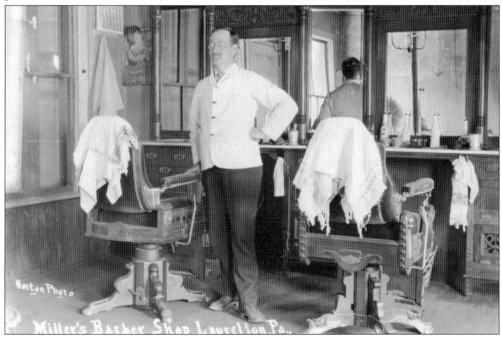

Laurelton was settled as early as 1772 when John Glover Sr., an Irishman, and his family settled near Spruce Run. Earlier names included Slabtown, Weikerville, and Laurel Run, but Laurelton won out. Francis Miller's barbershop in Laurelton is pictured here on a postcard mailed in 1908. Miller retired in 1925 after 38 years of barbering, and his son George took over the business. (UCHS 92.9.89.11.)

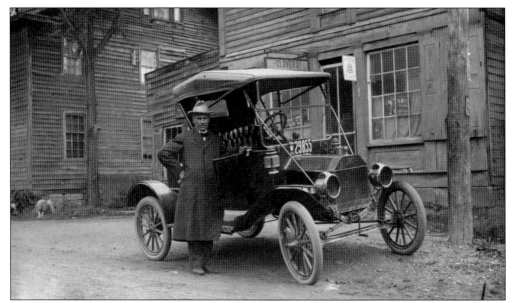

Dr. Oliver Wendell Holmes Glover, whose father came from Ireland, posed with his Model T Ford, often called a "Tin Lizzie" or "Flivver," in front of his drugstore and the office of Dr. George C. Mohn. The license plate shows the year 1912. Dr. Glover served the medical needs of Laurelton and area residents until his death in 1949. (UCHS 88.21.8.)

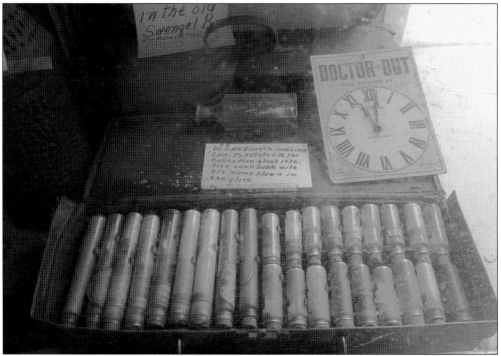

Dr. O.W.H. Glover's medicine case was presented to the Shively Family Museum collection about 1936. It included vials of medicinal powders and also a small bottle with Glover's name blown into the glass. The clock sign, indicating that the doctor is out, is no longer seen in the offices of private practices, which have receptionists and office staff to deal with schedules and paperwork. (MLH.)

The Hartley Township High School, also called the Laurelton High School, was built in 1905 and is seen here in 1948, just before the Mifflinburg jointure. By then, a freshman class had 15 members; by the time they were seniors, the class had nine. The old water pump stands to the left of the front door. (Courtesy of Eleanor Hoy.)

The class of 1948 was the last class to graduate from Hartley Township High School. Members of the class are, from left to right, (first row) Peggy Saugher, Dorothy Gross, Miriam Schell, Jean Lukens, Shirley Benner, and Clair Katherman; (second row) Eleanor Hoffman, David Hoffmaster, Paul Reamer (principal and teacher), Roger Zimmerman, and Martha Hackenburg (teacher). (Courtesy of Eleanor Hoy.)

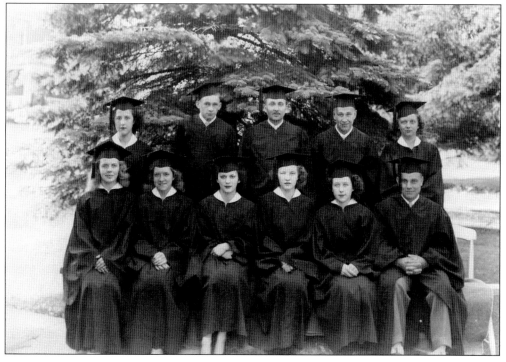

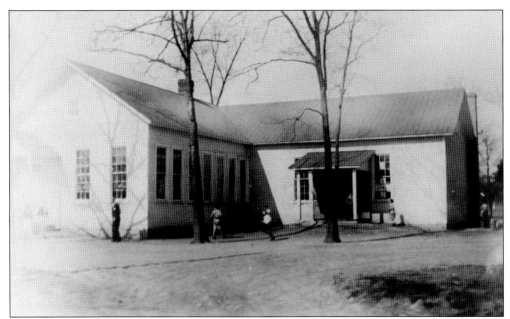

The Laurelton Elementary School was built in 1917 as an annex to the Laurelton High School for grades one through six when grammar schools in Hartley Township were consolidated. The building was taken over by the township after a new elementary school in Laurelton opened in 1952. The old elementary school was remodeled to create a community center and a polling place for Laurelton residents. (UCHS 89.5.3.48.)

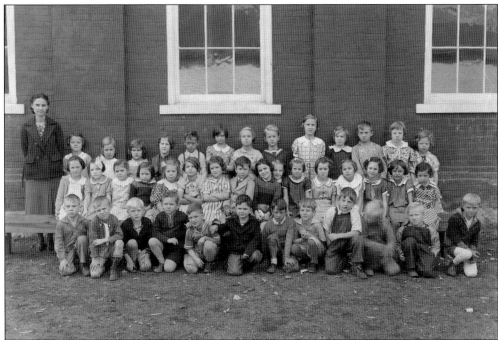

The first and second grades of Laurelton Elementary School pose here in 1937–1938. Amelia Schell was the teacher. The classes are standing at the side of the Hartley Township (Laurelton) High School. The elementary school building stands close by to its north. (Courtesy of Eleanor Hoy.)

The community center, next to the former Hartley Township High School, was built by combining five former one-room schoolhouses: Lincoln, Laurelton, Center Point, Pine Grove, and Hironimus (also referred to as "Weikert School"). The Community Center also housed the West End Library until the library moved into a new facility in 2006. (MLH.)

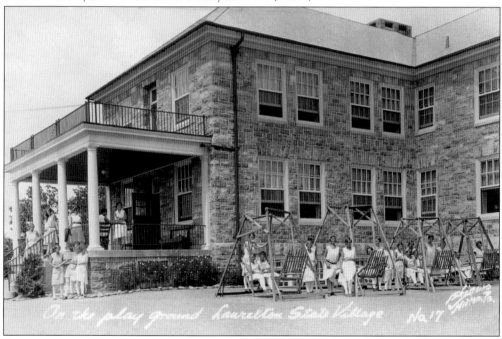

One of the residential cottages in the Laurelton State Village is seen here as the women relax on swings. The Laurelton State Village for Feeble-minded Women of Childbearing Age opened under the direction of Dr. Mary Wolfe, a Union County native and 1896 Bucknell University graduate, as the first superintendent. The first woman was admitted on January 2, 1920. (UCHS 2006.46.22.)

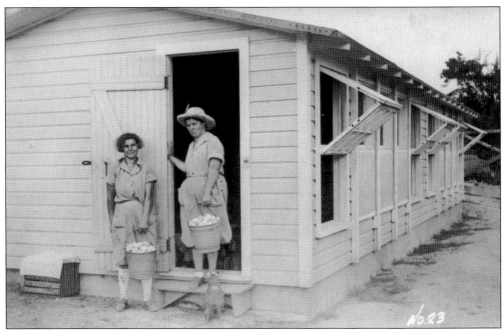

The residents of Laurelton Village are seen here at work in the poultry house and the barn. The village was almost self-sufficient in supplying its own food and shipped its surplus to other state institutions. As emphasis shifted to care and rehabilitation of the mentally disabled, the name changed in 1962 to Laurelton State School and Hospital and later to Laurelton Center. Men were first admitted in June 1968. The facility closed in June 1998. Residents of local communities often hired the women to do house-cleaning chores. During the time of its expansion and full complement of residents, the Laurelton Village provided surrounding communities with many employment opportunities. (Courtesy of Ronald Nornhold.)

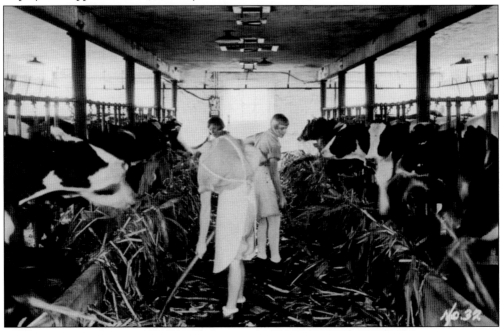

Two

WORKING

Work in Mifflinburg and the West End depended on the initiative and risk taking of its people. Agriculture was always an economic mainstay for Union County, but at the end of the 19th and beginning of the 20th centuries, Mifflinburg experienced a far-reaching economic development: the growth of the buggy industry. Entrepreneurs set up buggy factories while other enterprises supported those factories with parts and sales. Buggies shipped from Mifflinburg to the East and West, ultimately across the growing nation. Then, the Model T Ford arrived. Some buggy-makers adapted by producing bodies and body parts for the automobile. Again, the enterprise had a good run until the Detroit automakers began fabricating their own bodies. Other factories in Mifflinburg included knitting mills, silk mills, wood product companies, and agricultural support businesses.

The towns of the West End—Swengel, Millmont, Laurel Park, Glen Iron, Pardee, and Weikert—depended on the timbering industry, which experienced exponential growth with the coming of the railroad. Narrow-gauge railroads and trams reached into the mountains and hauled out the raw materials while lumber mills nearby pushed out thousands of feet of cut lumber. The towns thrived. Churches, stores, railroad depots, hotels, and fancy homes marked the wealth and gave evidence of a booming industry until the timber ran out.

Hartleton missed the railroad by a mile. Its growth came from the turnpike, today's Route 45. It was a convenient stop along the way to Centre County for folks on their way to Bellefonte or Penn State football games. The roads eventually became smoother, the cars faster, and Hartleton was left by the wayside. Laurelton was missed by the railroad and the turnpike, but its gristmill lasted for over a century.

Today, Mifflinburg has a number of small industries, including those that continue to produce wood products. The West End now has second- and third-growth timber, but it is not for industry. The woods provide outdoor vacations for many with hunting and fishing camps and summer houses along Penns Creek.

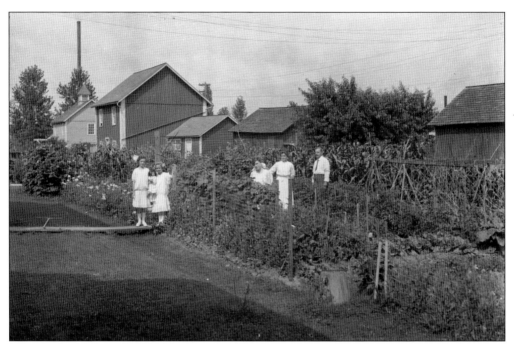

Farms always surrounded the borough of Mifflinburg, but some borough residents did their part in backyard gardens. John and Emily Foster, with their two daughters Lucretia (far left) and Helen (next to her mother), visit the home and garden of John and Hannah Kistler. The Kistler daughter Julia holds a doll, probably a gift from the Fosters, who boarded with the Kistlers at one time. (UCHS JD.)

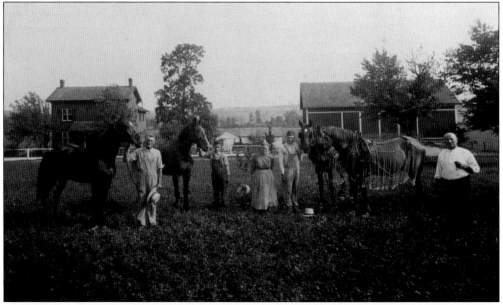

Alexander and Sarah (King) Dersham's farm is seen here in 1912. Standing, from left to right, are Alexander Dersham, farmer, carpenter, and buggy-maker; Luther, who died in World War I; Sarah Dersham; Mr. Lewis, also a farmer near Mifflinburg; and possibly Vincent Smith, the photographer. The farm is located on Grand Valley Road. (Courtesy of John Dersham.)

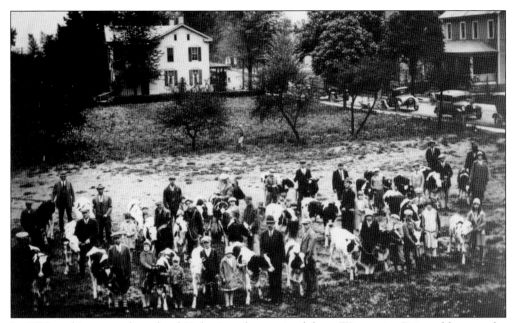

In 1928, a shipment of purebred Holstein calves arrived from Wisconsin. Pictured here at the C.E. Shively lot on Walnut Street in Mifflinburg are the 4-Hers who had each been chosen by lot to receive a calf. The tall, mustached gentleman in the center foreground is county extension agent Cromer. (UCHS 89.5.9.14.)

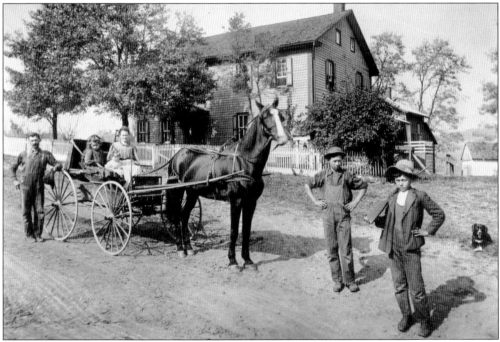

The Charles Grove family is pictured here in front of their farmhouse about 1910. Standing at left is Charles Grove. Seated in the carriage are Caroline, Bertha, and Bertha Royer Grove; standing at right are Robert and George. George later served in World War I and established the Mifflinburg Hardware Store. The house still stands on Snake Hill Road. (Courtesy of Jeanne Grove Zimmerman.)

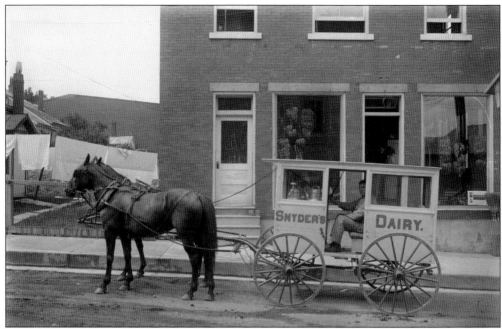

Albert Snyder of Mifflinburg poses in his dairy wagon in front of James Beaver's fruit store on North Fourth Street about 1920. Snyder would take the anticipated amount of milk from the tank and pour it into a kettle. Milkmen frequently hired schoolboys to help them on their early-morning dairy routes before dropping them off at school. (UCHS JD.)

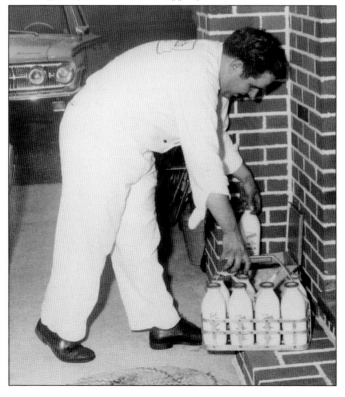

The milkman often arrived before daylight. Fresh milk at the door is a convenience no longer enjoyed in modern times. Sometimes, if requested, the milkman would place the bottles in the customer's refrigerator, especially if no one would be home for some time. Customers might also leave payment on the kitchen table or in the box beside the door. This photograph is from 1967. (MBM SC.)

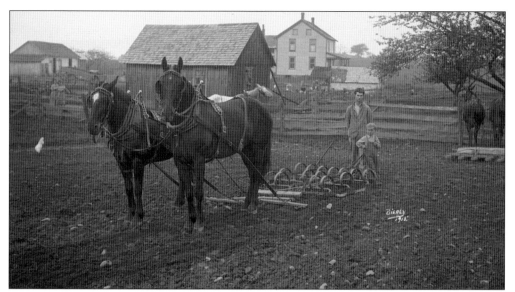

Raymond and his little brother Charles Bowersox work on their family farm located northwest of Mifflinburg on Grand Valley Road. Their parents, Floyd and Verna Bowersox, purchased the farm from the estate of Levi L. Shoemaker in 1908. The family sold the farm in 1959 after the deaths of Floyd and Verna. The house and the spring house to its right in this 1915 photograph still exist. (UCHS JD.)

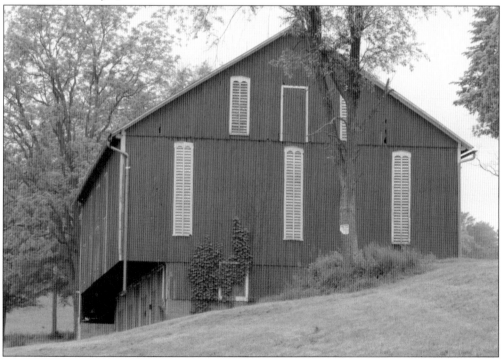

This red barn, located on Creek Road on lands previously owned by Harry Boop, is a good example of the Pennsylvania barn. Built into the side of a hill, the main level is easily accessed by machinery up a short ramp. The lower downhill level with its overhang, also called the forebay, houses livestock. This structure contrasts with the English barn with its gambrel roof. (MLH.)

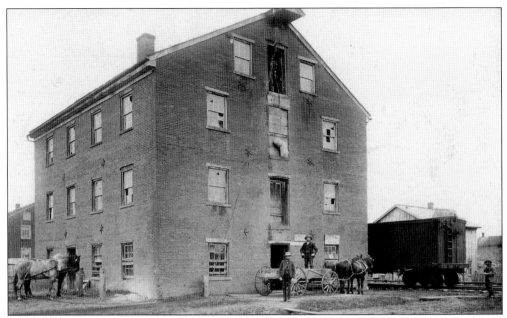

James H. Snook purchased the Mifflinburg Flour and Feed Mill about 1931. It was originally built by Elias Derr in 1840. Snook sold it to his son Quentin in 1947. Over the years, extensive improvements were added, including a grain drier, bulk grain-handling machinery, a feed-pelleting mill, and an automated feed-mixing complex. Agway, Inc. purchased the mill complex in 1987. (Courtesy of John Snook through MBM.)

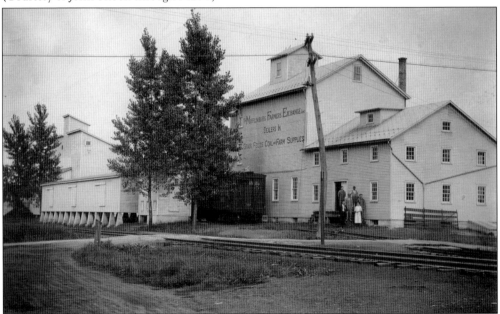

The Mifflinburg Farmers Exchange was founded in 1912, and its first feed mill was constructed in 1920. The exchange expanded its services and products over the years to include grinding, manufacturing, sampling, and analysis of feed; soil sampling; stove installing; corn shelling; drying, marketing, and storing of grain; and custom fertilizer spreading. The company opened the Country Farm and Home Garden Center on Route 45 in 1990. (MBM SC.)

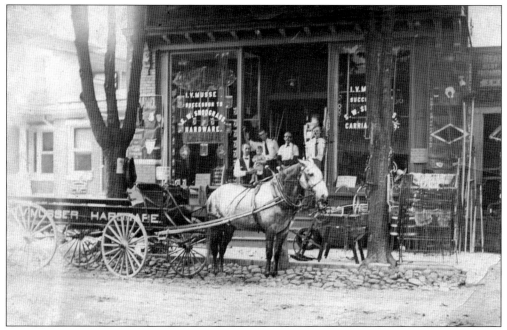

I.V. Musser Hardware on Chestnut Street is seen here in the early 1900s. It was located on the east side of the firehouse. The Musser Hardware Store was a successor to the S.W. Snodgrass Hardware Store, which was founded in 1869. In 1880, the stock consisted of shelf hardware, paints, oils, glass, a complete line of carriage goods, and mechanical tools. (Courtesy of Agnes Rathfon.)

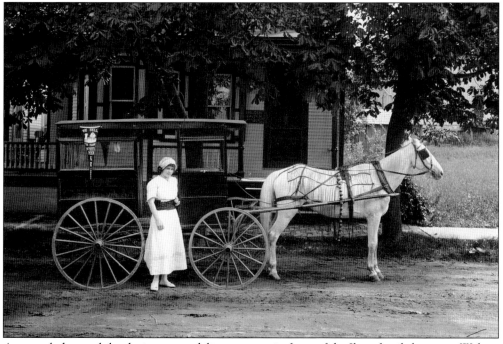

A young lady stands by the ice cream delivery wagon in front of the Ilgen family house on Walnut Street. The Ilgens, descendants of the first minister of the Elias Church, sold ice cream from a dairy in White Deer. (UCHS JD.)

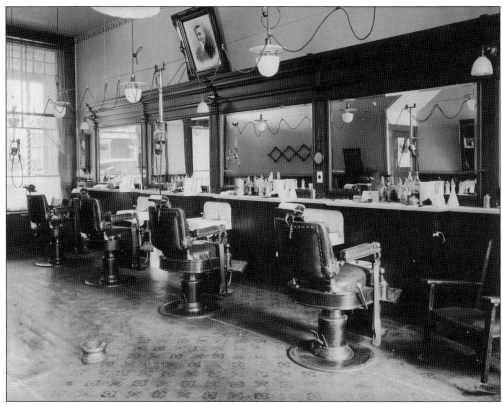

The Heiter barbershop, seen here about 1926, was located at 354 Chestnut Street. It began by providing barber service at the request of customers of the owner's harness shop. Three generations of Heiters have carried on the barbershop trade in Union County for over 100 years. A portrait of founder Augustus Heiter looks out over the establishment from high above the mirrors. (UCHS 89.5.15.43.)

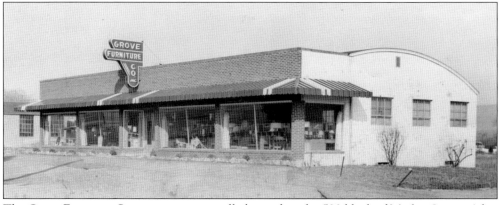

The Grove Furniture Company was originally located in the 500 block of Market Street. After a fire destroyed much of that building, George Grove built a new store on the north side of East Chestnut and Line Streets, seen here in the late 1950s. The building was sold to Shipton Brothers in 1959. It is now A+ Office Outlet. (Courtesy of Jeanne Grove Zimmerman.)

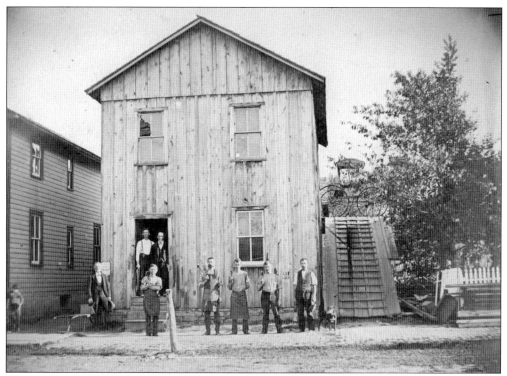

The original building of John Gutelius and Son Carriage Works was located at 521 Market Street, seen here about 1875. John stands in the doorway to the left. This is just one of the Gutelius family shops that spanned the period from 1841 to 1920, producing sleighs, wagons, buggies, and finally bodies for trucks and station wagons. (UCHS 1994.32.63.)

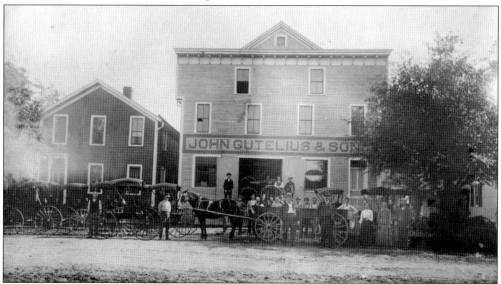

The original Gutelius building at 521 Market Street was moved to the back of the lot and replaced by this larger structure. John Gutelius stands on the platform to the left, and David Gutelius is the heavyset man in the center. Carriages are lined up and ready to be taken to a fair. In front of the carriage at the right are, from left to right, Ida, Sarah, and Thomas Gutelius. (UCHS 1994.32.64.)

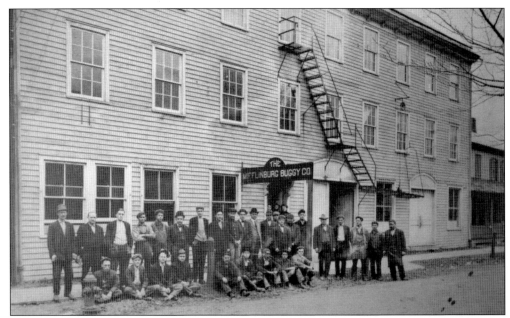

The Mifflinburg Buggy Company on Walnut Street near Fourth, seen here in 1910, was founded in 1897 on the site of the earlier Thomas Gutelius buggy works. In 1900, the company had approximately 30 employees, producing up to 12 buggies a day and about 700 per year. The founders, Alfred A. Hopp, Harry F. Blair, and Robert S. Gutelius, adopted mass production techniques in order to compete, as had others. (MBM SC.)

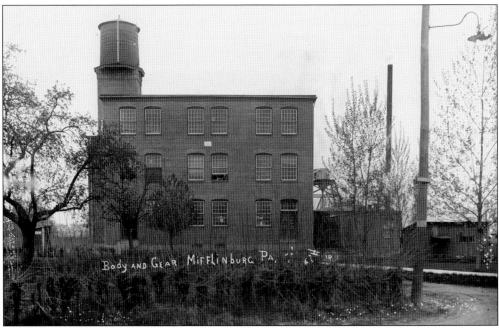

In 1911, with the success of the Model T, a group of local investors headed by Horace Orwig organized the Mifflinburg Body and Gear Company. They erected a large three-story factory, power plant, and kiln west of North Eighth Street, seen here in 1914, to manufacture ironwork and bodies for both carriages and automobiles. (UCHS 92.9.89.45.)

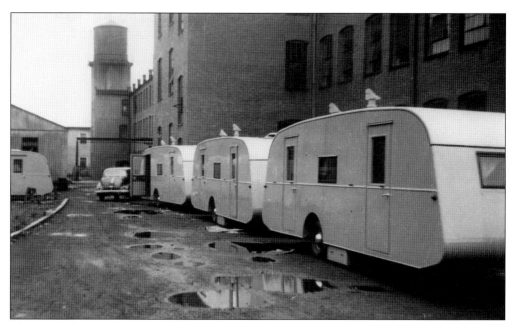

The Mifflinburg Body and Gear Company merged into the Mifflinburg Buggy Company in 1916. It became the Mifflinburg Body Company in 1918 and produced car bodies and furniture. By 1943, the American Billiards and Bowling Company owned the facility and changed the name to the Mifflinburg Body Works. Seen here in 1941, the much-expanded facility on North Eighth Street produced these trailers for military personnel. (MBM SC.)

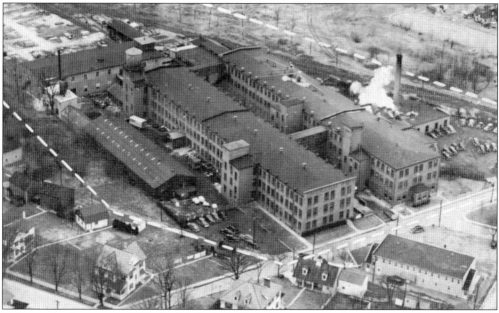

Before its bankruptcy in 1943, the Mifflinburg Body Company produced thousands of automobile and truck bodies. By 1923, it had more than 300 employees. This 1954 postcard shows how much the company had expanded, but by this time, the 250,000-square-foot complex had been sold to the Reconstruction Finance Corporation and then in 1956 to Mifflinburg Industries, Inc. (UCHS 93.10.4.)

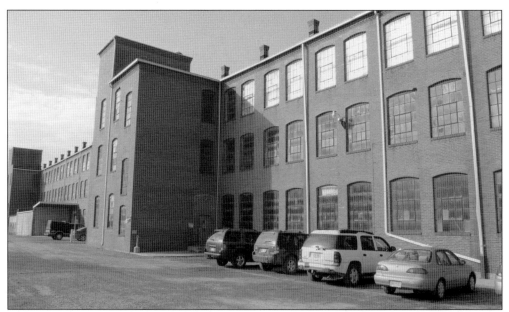

Mifflinburg Industries merged in 1968 into Colonial Products Company, which merged into the Wickes Corporation, of which Yorktowne Corporation was a division. Yorktowne owned the property until 1993. The land is currently owned by EY, Inc., a Pennsylvania corporation. Operating in the complex are Ritz-Craft Corporation and Legacy Building Products, both manufacturers of home building products. (MLH.)

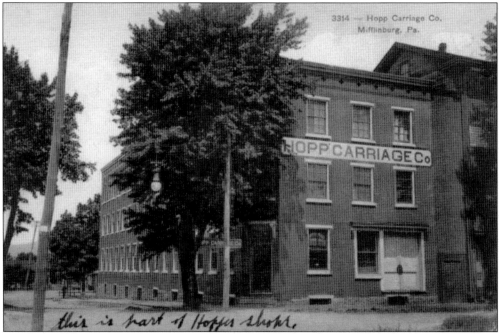

The Hopp Carriage Company was located at the corner of Fourth and Walnut Streets, seen here in 1910. The building to the right was formerly Sankey Hall, into which the Hopp Company expanded. Alfred A. Hopp withdrew from the partnership in the Mifflinburg Buggy Company in 1903 and formed his own factory, becoming a major rival and producing up to 2,000 vehicles annually. (UCHS.)

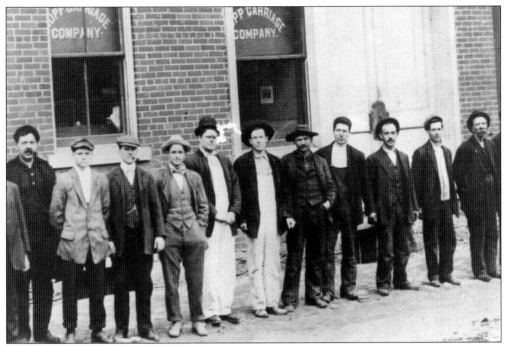

Hopp Carriage Company employees pose in front of the plant in 1910. The buggy trade had its risks. When the economy went soft, buyers postponed their purchases, making do with or repairing what they already had. The buggy trade was ultimately doomed, and in 1922, the Hopp factory closed. As Charles Snyder reports, buggy shops were closing across the entire nation by the thousands. (UCHS 89.5.11.9.)

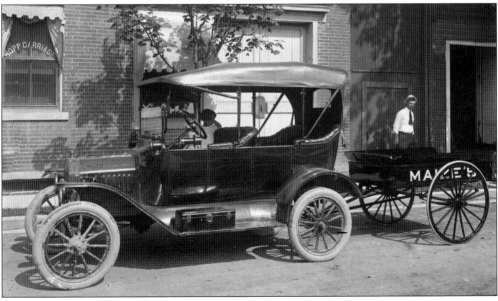

Howard "Dickie" Hopp stands at the right of a Ford with a new trailer produced by the Hopp Carriage Company in 1920. Buggy companies prospered for a while by producing truck and automobile bodies, but carmakers eventually started producing bodies in their own factories. By 1927, the Kooltex Underwear Corporation occupied the Hopp Carriage Building. (UCHS 2006.35.21.)

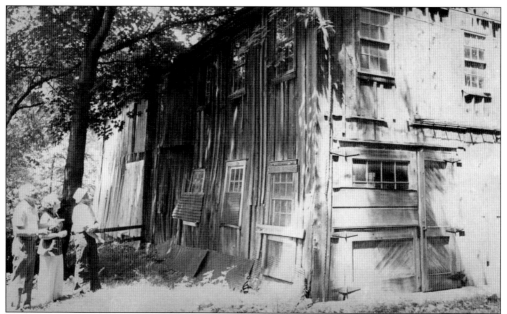

Charles Snyder dramatically describes the moment as follows: "Spring 1978, on a Sunday afternoon late in May, Owen Heiss, grandson of William and Anna Heiss, opened the door to an unbelievable sight." It was the W.A. Heiss Coach Works, almost intact, as if William Heiss had just left for awhile, intending to return. The photograph shows, from left to right, Charles Snyder, Katherine Roush, and Norman Heiss investigating. (UCHS 89.5.11.56.)

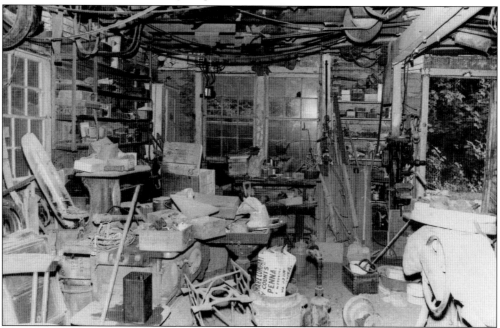

William Heiss opened his factory in 1883 and stopped making buggies in 1920. This photograph shows the interior of the blacksmith shop as it appeared in 1978 after its rediscovery. The shop contains a drill press in the center. Belts and pulleys hang overhead, installed in 1915, to assist in making furniture, also a Heiss product. William Heiss died in 1931. (UCHS 89.5.11.7.)

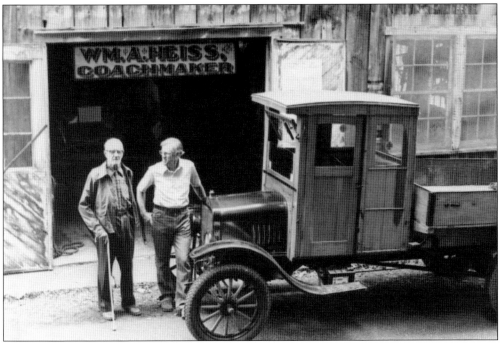

The William Heiss buggy shop in Mifflinburg produced one dump truck using buggy hardware on the Model T Ford chassis. The truck was built for a job Norman Heiss had hauling stones when Route 15 was expanded north of Lewisburg. This photograph shows Norman, eldest son of William Heiss, and Owen, grandson of William, next to the 1920 truck. (UCHS 89.5.11.11.)

Enoch Miller's Planing Mill, opened in 1883, was located on North Eighth Street beside the railroad tracks. In this 1900 photograph, from left to right, employees Harry Shirey, unidentified, Benjamin Tittle, Harry Smith, Eli Groover, Harry Wilkinson, and George Solomon pose in front of the mill. Charles Snyder called Enoch Miller a "painstaking yet imaginative builder." His homes, churches, stores, and banks still stand on the Mifflinburg landscape. (MBM SC.)

John Rogers opened a farm machinery outlet in the former Mifflinburg Buggy Company Repository in the 300 block of Walnut Street about 1921. Here, the massive tractors line Walnut Street on display. The building later housed the Smith Bottling Works and, still later, the James Zimmerman apartments. (MBM SC.)

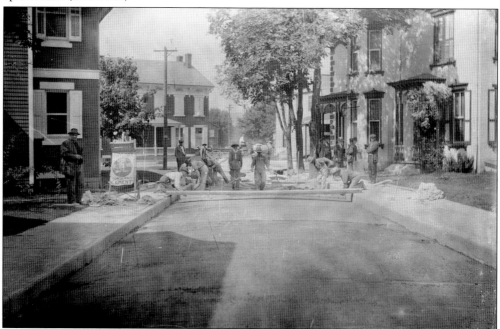

No more mud or clumsy cobblestones! Third Street in Mifflinburg was paved around 1917. It was the first piece of concrete paving in Union County and stretched up Third Street from Chestnut Street to the alley. Previously, Third Street was cobblestone. Chestnut Street was paved with concrete by 1920. Sunday drivers could then drive faster and farther more comfortably. (UCHS JD.)

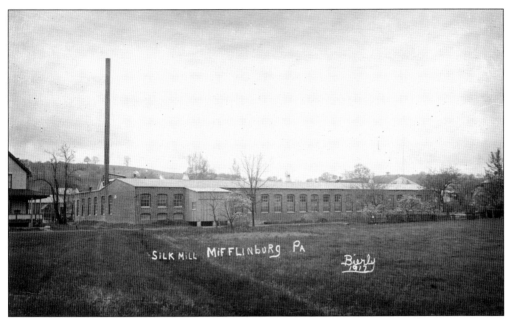

F.Q. Hartman founded Mifflinburg's first silk mill in 1916–1917 on the corner of Walnut and Second Streets. It had steam power and a high stack. Ownership passed on to the Villa brothers and then to the Berrizzi brothers, who hired about 100 workers, 80 percent of whom were women. The silk mill, seen here in 1917, was Mifflinburg's first employer to hire a large number of women. (UCHS JD.)

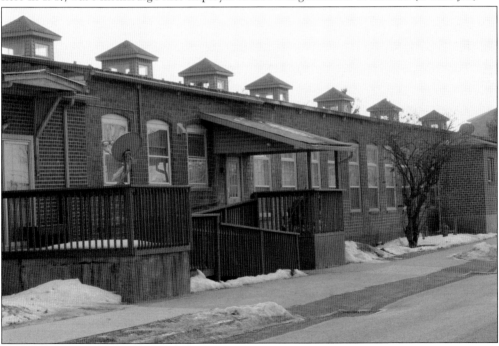

The old silk mill became the Huntingdon Throwing Mills in 1943, and the plant was significantly enlarged. Oscar Norris managed the mill for 35 years and served as president for another four years until 1982. In 2001, the property was sold to Franklin Reber and Robert Lauver and converted to apartments, as seen in this recent photograph. (MLH.)

In 1899, Kreider Kurtz and his brother Newton opened the Kurtz Overall Factory across from the Mifflinburg railroad depot. Taking power from a gasoline engine and later from electric engines, belts from the main shaft powered 12 stitching machines, two fell-seam machines, and the button hole and button machines. Business remained steady until the Great Depression. The factory closed in the late 1930s. (MBM SC.)

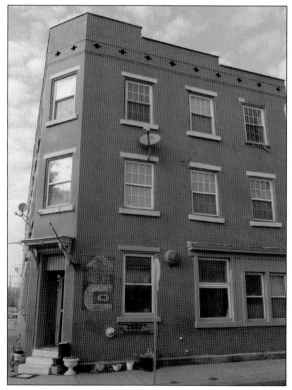

The Hopp Carriage Company Building passed on to Kooltex Underwear in 1927, later called Kooltex Knitting Mill. It later became Par-Knit Mills, which manufactured pajamas and sportswear. The building was reconfigured into apartments about 1996. The photograph shows an unpainted rectangle to the right of the door in which the lower part of "X" and the "Co" for "Company," the last vestige of the Kooltex Company, is visible. (MLH.)

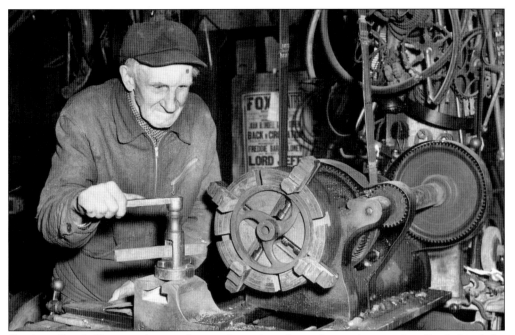

Gardner Gotshall is seen here in his machine, bicycle, and auto shop in the alley behind the Mifflinburg Hotel. He had the reputation of being able to fix anything! He was also a dealer in copper and iron. Kids brought him odds and ends and always managed to get a nickel or two from him. Gotshall died in 1960. (MBM SC.)

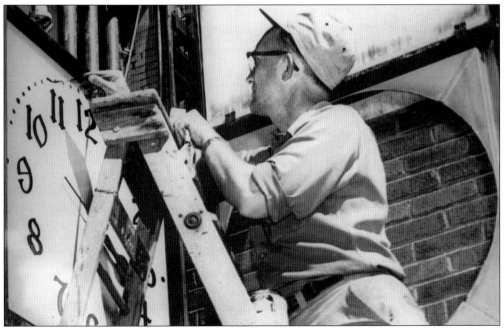

Robert Minium paints the clock for the Mifflinburg Bank & Trust Company about 1947. The clock served Mifflinburg residents and drivers passing through by reminding them to pace their way. The bank building at 343 Chestnut Street is now used by county administrative offices. (Courtesy of David Goehring.)

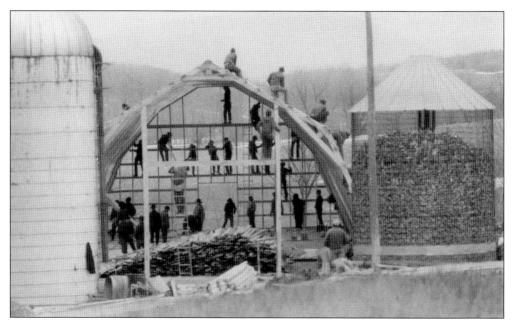

The Amish and Mennonites have long been part of Union County history, but the number of communities increased substantially in the 1970s when land prices in Lancaster County escalated. When tragedy strikes, the plain people help others in need. This barn raising at the Zimmerman farm, one week after the barn burned, demonstrates the power of community in this population. (UCHS 89.5.9.6c.)

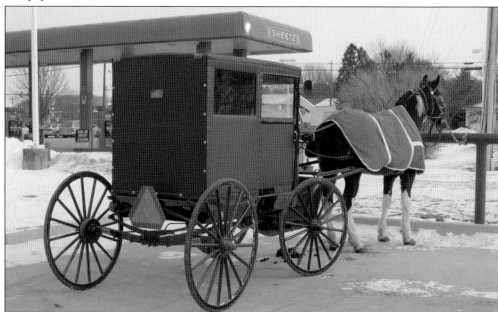

This horse and buggy is parked outside of Weis Markets on the east side of Mifflinburg. The modern Sheetz Gasoline station stands in the background; it opened in 1999 when gasoline sold for $1.09 per gallon. Horse-drawn buggies are a common sight on roads in Central Pennsylvania and are a primary means of transportation for members of the Old Order Amish and Old Order Mennonite communities. (MLH.)

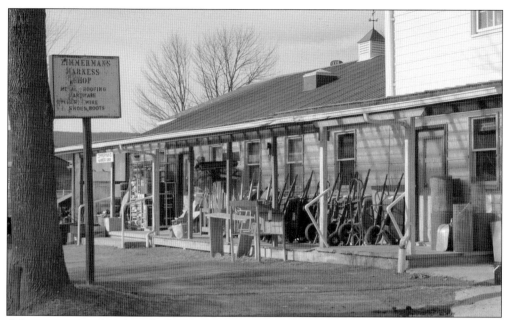

A longtime popular shop for local Amish and Mennonites, Zimmerman's Harness Shop is a busy place on Kaiser Run Road. Daniel H. Zimmerman founded the business in 1969. As more Mennonites moved into the valley, the business grew as neighbors needed Zimmerman's leatherworking expertise. His son Adin later took control of the business, expanding the variety of items stocked. (MLH)

West of Mifflinburg on Kaiser Run Road in Lewis Township stands the Mountain View Church, a Mennonite meetinghouse. It has separate doors for men and women and multiple parking garages to shelter buggies and horses. Members of the Wenger, or Team Mennonites, drive black buggies. The various colors of buggy tops serve, in part, to differentiate Old Order communities. (MLH.)

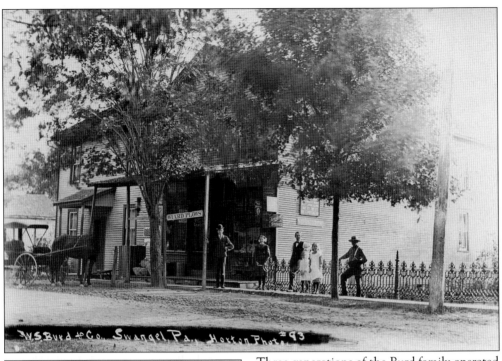

BURD'S STORE
SWENGEL, - -:- - PENNA.

Silver Floss Sour-kraut,	..	Can 19¢
Evaporated Milk, .	..	4 Cans 39¢
Soup Beans, Great Northern		2 Lbs. 25¢
Baby Lima Beans, . . .		2 Lbs. 29¢
Cope's Dried Corn, .	.	Can 19¢
Baking Syrup, Barrel ...		Qt. 32¢
Large Sweet Peas,	.	2 Cans 31¢
Stokely's Peaches,	.	Can 33¢
Red Kidney Beans, .	..	Can 12¢
Waldorf Toilet Tissue,	..	. 6 Rolls 29¢
Rinso Soap Powder,	. .	. Pkg. 25¢
Stokely's Sweet Orange Marmalade .		.. Qt. Jar 39¢
Indian Balsam Cough Syrup	..	Bottle 23¢

Men's Covert Work Pants Pr.	$2.06
Men's Covert Work Shirts .	$1.23
Bleached Muslin	Yd. 27¢
Towels 18x33 Hemstitched	Each 29¢

Artics - Ladies' & Misses' 2 Snap	$1.75
Artics - Men's, 4 Buckle Heavy	$4.19
Artics - Boys', 3 Buckle Heavy	$3.15

.22 Short Rifle Shells	Box 25¢
.22 Long Rifle Shells .	Box 35¢

Endicott Johnson and Peterman Shoes
Dress - Play - Work

Three generations of the Burd family operated general merchandise stores in Swengel. William L. Burd opened one in 1894, seen here between 1907 and 1911. William also served as postmaster. After his death in 1913, his son Clarence took over, and Clarence's younger brother Authur R. "Peck" Burd succeeded him. This building was destroyed by fire in the 1980s. (UCHS 88.21.5.)

This advertisement of Burd's general store in Swengel demonstrates just how "general" the merchandise was. Early general stores, such as Burd's, often housed the post office and became a focal point of the community. Peck Burd competed aggressively by launching special sales, handing out flyers, and holding auctions outside the store on Saturday evenings during the summer. (UCHS 92.9.89.26.)

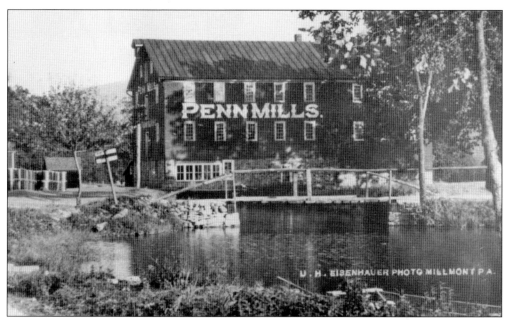

The Halfpenny and Grove Mill, located near Swengel, was built by David Smith in 1781. After improvements by various owners, Lincoln Halfpenny and Abram Grove acquired it in the early 1890s and produced flour and feed. In 1903, the mill was turned into a water-generated electric power plant, providing electricity to Mifflinburg. The initial cost for electricity was set at $1 for each lightbulb per year. (UCHS 89.5.6.1.)

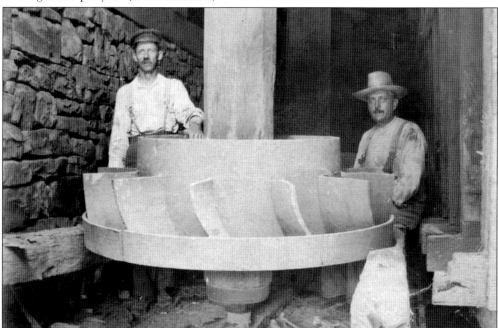

In the late 1800s, horizontal turbines replaced older vertical water wheels in many gristmills. In the Halfpenny Mill, two workers stand by the main blade assembly for a horizontal turbine fixed to a large wooden shaft and resting on a bearing block at the bottom of the turbine pit. Water falling through the turbine pushed against the curved blades to spin the shaft. (UCHS 89.5.6.4.)

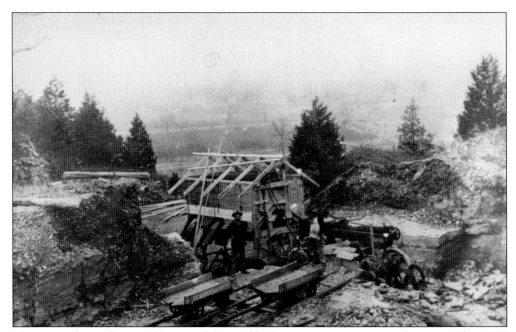

The quarry located on a ridge east of Swengel had numerous owners over the years. This 1907 view of the stone crusher shows rails being used to transport the stone. The operation supplied crushed limestone; some of it was used for road construction, and some was ground into lime and used in the iron-smelting operation in Glen Iron. (UCHS 89.5.15.10.)

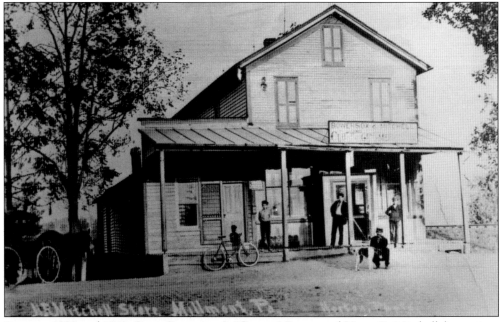

Between 1899 and 1918, Oscar Bowersox, J. "George" Royer, and Harry R. Mitchell (in various combinations) operated this general store in Millmont. In 1918, Newton Shirk took it over, eventually selling the business to his son and daughter-in-law, Donald and Delphia Shirk, around 1961. The Shirks jointly operated the store for about 30 years. Delphia kept the business open until 2010. (UCHS 89.5.15.12.)

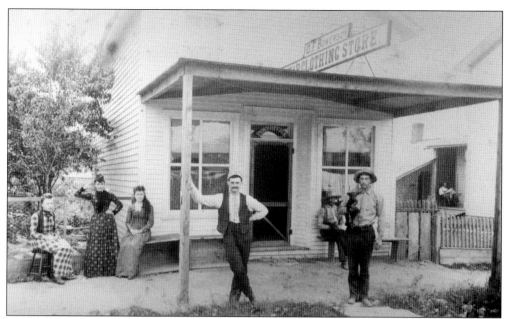

The Oscar Bowersox Cheap Clothing Store was located at the west end of Maple Street in Millmont. Bowersox is seen here about 1890, leaning against the post. Bowersox was also postmaster in Millmont during this time, and the post office was located in the store. Bowersox had competition from other stores in Millmont, and perhaps "cheap" was his marketing gimmick. (Courtesy of Tony Shively.)

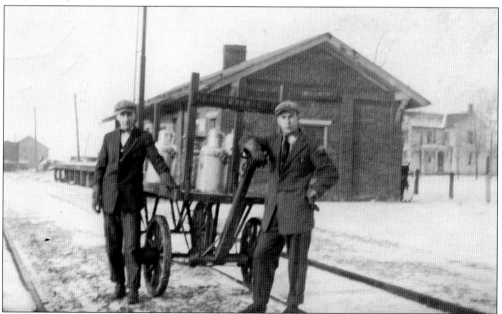

Ernest Ruhl (left) and Abby Wert stand with a milk shipment ready for the morning train at Millmont in 1911. According to Hertha Wehr, as early as 1907, records indicate that the Mifflinburg Creamery Company accepted milk in cans for train shipment to larger population centers. In the early 1940s, the Mifflinburg plant discontinued taking milk, which was then shipped to a receiving station in Milton. (UCHS 88.21.3.)

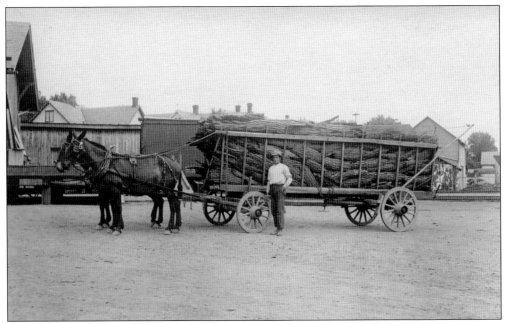

This wagon filled with hemlock bark ready to be used at tanneries was photographed in 1906. In that year, the *Lewisburg Chronicle* reported that Pennsylvania furnished more bark for tanning than any other state in the nation, some 379,773 cords in 1905. (UCHS 85.15.5.)

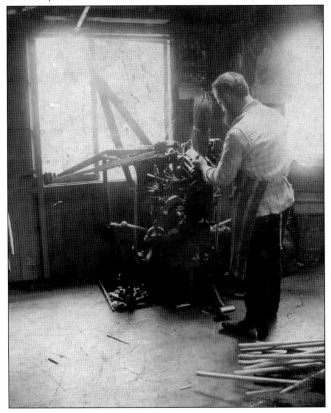

Greene Shively learned the broom-making trade to augment his income as a minister. He moved his family and business to Millmont in 1918, occupying the corner of Millmont Road and Maple Street. Productivity increased significantly after he purchased a sewing machine. In 1919, sales exceeded 12,000 brooms for the year. Shively's son Jacob halted operations by 1929. (Courtesy of Tony Shively.)

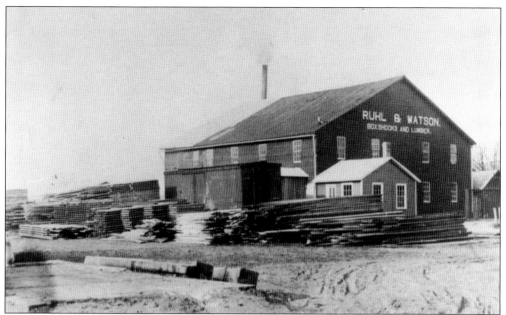

From 1883 until 1951, the Ruhl and Watson Lumber Company, also called the Box Factory, employed 20 to 30 men in Millmont. Products included box shooks (unassembled wooden boxes and crates), flooring, plaster lath, wainscoting, window sash and boxing, doors, porch columns, and shutters. The factory burned down in 1912; it was rebuilt and again destroyed by fire in 1951. (UCHS 89.5.5.6.)

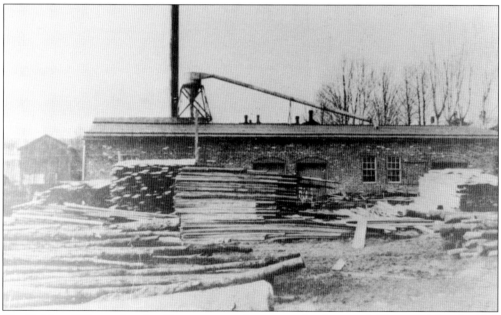

The Ruhl and Watson Lumber Company was the principal industry in Millmont. After the 1912 fire destroyed the two-story, wooden structure, Ruhl and Watson rebuilt the factory four months later, this time as a one-story, brick building. Ruhl and Watson sold the business in 1922. The Millmont Box Factory continued under different owners and later produced plywood cores for assembly as radio and television cabinets. (UCHS 89.5.5.6A.)

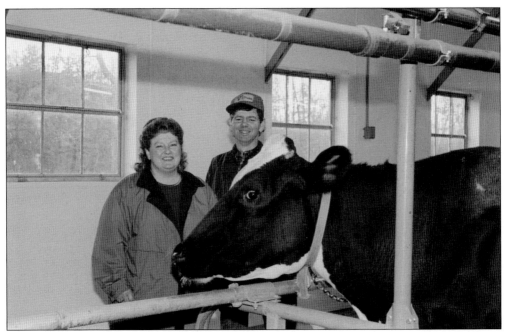

Gerald and Kathy Boop are pictured around 1999 in the modern barn they built to hold 40 head of Holstein cows. Their farm, which has been in the family since 1780, is located on the south side of Penns Creek, southwest of Millmont. Over the centuries, technological efficiencies have dramatically increased farm productivity and yields. (UCHS.)

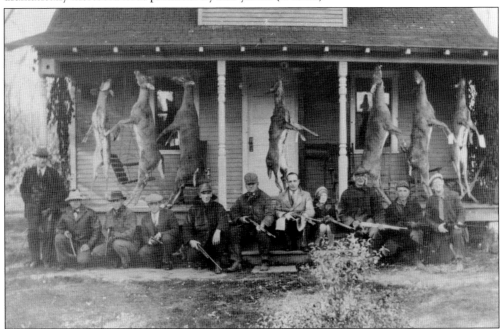

Hunting may be for leisure but it also adds meat to the table during the lean times of the year. In the early 1960s at this cabin north of the West End Fairgrounds along Laurel Run, hunters include, from left to right, three unidentified, Nevin Schnure, Ben Burns, Merrill Schnure, Sam Schnure, unidentified, Jessie Pick, Bud Yeager, and unidentified. (UCHS 89.5.1.8.)

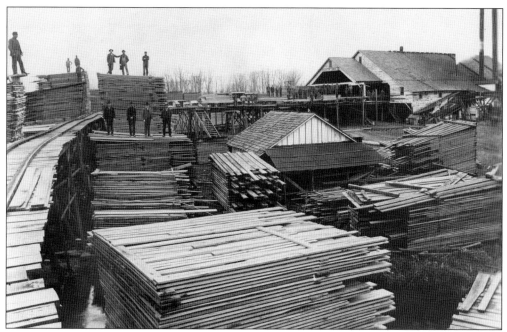

Samuel W. Rutherford, a storekeeper, joined in partnership with Dr. George Calvin Mohn, a local physician, to form the Laurelton Lumber Company on leased land in Laurel Park adjacent to the railroad, one mile east of Glen Iron. In this 1894 photograph of the company mill, Samuel Rutherford stands on the far left. (UCHS 89.5.5.9.)

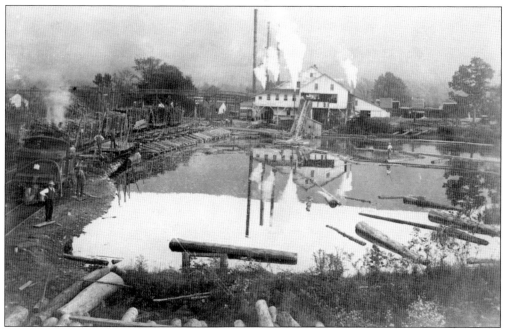

In 1897–1898, the Laurelton Lumber Company ran a narrow-gauge track north to the south slope of Paddy Mountain. The steam-powered locomotives were referred to as "dinkeys." In this photograph, dated about 1904, one sees the dinkey engine and tracks to the left and the mill reflected in the millpond, fed by Laurel Run, in the center. (UCHS 83.3.18.4T.)

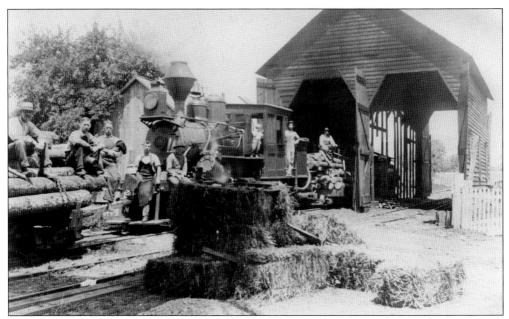

The Laurelton Lumber Company narrow-gauge tracks reached far into the mountains, making more of the timber accessible. The company used dinkey engines while wildcatting on some of the branches. Wildcatting allowed gravity-driven log cars with brakes and a brakeman, but no power, to careen down the mountainside. In this photograph, Engine No. 2 stands at the engine house located along Weikert Road in Laurelton. (UCHS 2010.21.180.)

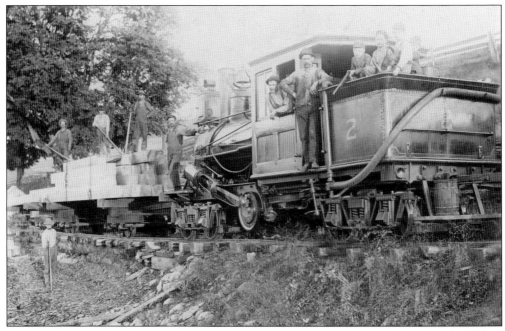

The Laurelton Lumber Company locomotive appears to be new in this 1893 photograph. All logs were stacked onto the cars by hand. If the company had owned a loader, the logs could have been piled higher. Mohn and Rutherford sold out to Whitman and Steele, who continued operations until 1909. (UCHS 2010.21.180.)

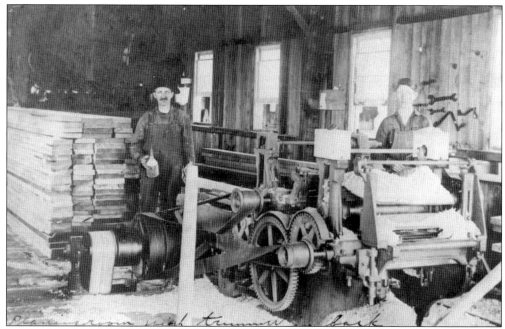

At Laurel Park, the sawmill ran year round. According to Charles Snyder, "Utilizing a band saw, lath mill, shingle mill, edger, trimmer, planer, three stream engines, and carbide lights, mill production reached 85,000 board-feet daily, filling five boxcars." A fire leveled the mill in 1907. Enough of the mill was rebuilt to finish operations in 1909 and close. (UCHS 89.5.5.4.)

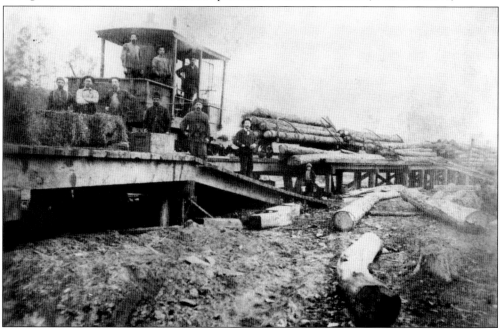

Ario Pardee (1810–1892) purchased vast tracts of forestland in Central Pennsylvania during 1870. He needed mine props for his anthracite-mining operations in Luzerne County. Mine props were shipped without further cutting over the Pennsylvania Railroad to the Shamokin area. The original Climax locomotive stands at Pardee station about 1888. (UCHS 2010.21.180.)

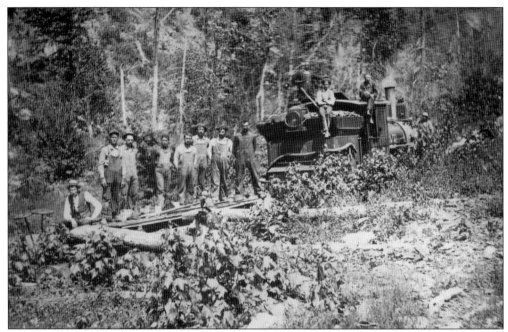

The timber industry expanded into the mountain forests as far as economically feasible. Workers, living in isolated camps, walked still farther to fell trees, often a mile or so. Engine No. 3 of the Laurelton & Penns Creek Railroad worked deep in the woods. Some timbering operations went bankrupt, but the owners of others enjoyed substantial wealth. (UCHS 2010.21.180.)

The Snyder-Middlesworth Park, near Weikert but over the ridge into Snyder County, contrasted starkly with the slopes of Union County, where the timber industry had denuded the mountains of trees. This photograph offers an inkling of what the old growth would have looked like. When comparing the two areas, old-timers insisted that they had sawed still larger trees in their days of Union County timbering. (UCHS 82.2.41.)

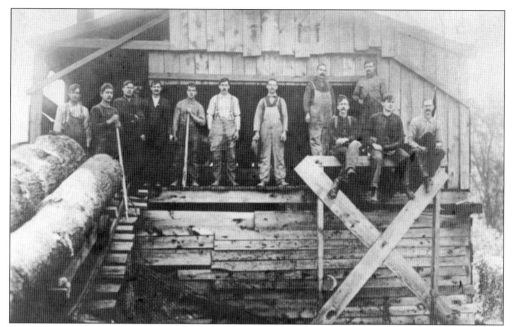

The mill at Pardee, located four miles west of Glen Iron, operated from 1886 to 1903. It connected by rail to the Lewisburg & Tyrone Railroad and produced 70 carloads of mine props in a month. The mill was run by steam power and had a circular saw, which had the capacity to cut 35,000 to 40,000 feet of lumber daily. (Courtesy of Ronald Nornhold.)

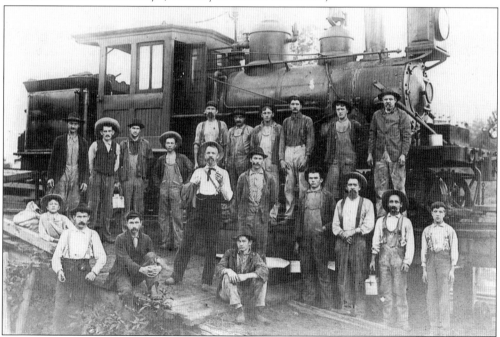

Workers of the Pardee Lumber Company pose by Engine No. 121 about 1900. Identified are Al Lichtenwalter, supervisor of the operation, standing with hands on suspenders in the center; David Libby, left foreground; Penrose Knepper, first from the right beside the engine; and John Rheppart, fifth from the right beside the engine. (UCHS 2010.21.180.)

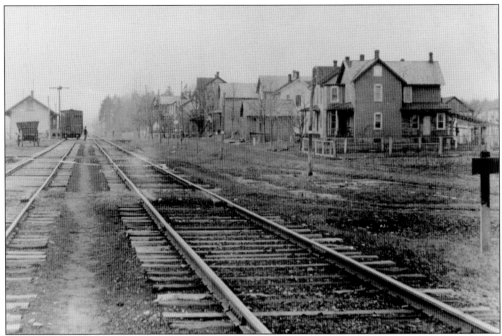

During 1872 and 1873, the railroad was slowly being built westward, eventually reaching Glen Iron, where it serviced the Berlin Furnace with a siding. The financial turmoil in 1873 halted further construction of the railroad until 1876. During the intervening years, the Glen Iron station, seen here on the far left in the 1890s, served as the railhead. (UCHS 89.5.11.54.)

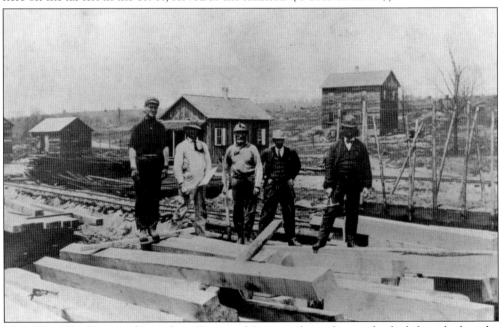

The railroad had bypassed Laurelton. Raymond Bogenrief, standing at the far left, picked up the mail at the Glen Iron station and transported it to the Laurelton Post Office. Using a Model T station wagon, Bogenrief also picked up passengers in the early 1920s and conveyed them to Laurelton. (UCHS 89.5.11.53.)

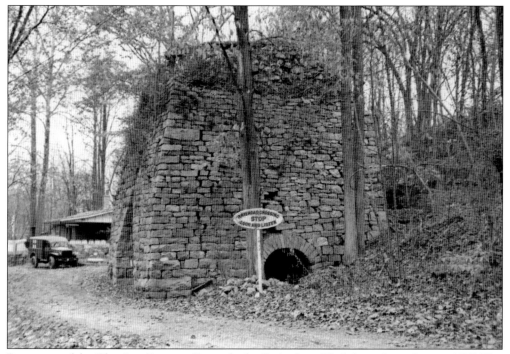

Remnants of the Glen Iron Furnace (formerly the Berlin Iron Works) are shown here in 1975. The furnace was used to "burn" the rocks containing iron. The pig iron would run out the bottom, harden in molds in sand, and then be shipped to mills for further refining. A vault at the base was used to remove slag or to admit air blast. The furnace closed in the 1920s. (MBM.)

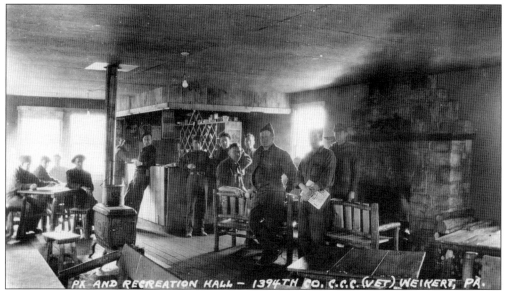

The Reforestation and Relief Act, signed into law by Pres. Franklin Roosevelt in 1933, created the Civilian Conservation Corps as one of Roosevelt's New Deal programs. The CCC was involved in extensive reforestation, bridge and trail building, and road maintenance. At the CCC camp at Weikert, the corps post exchange and recreation hall was completed in 1934, one of the last buildings to be erected. (UCHS 92.9.89.5.)

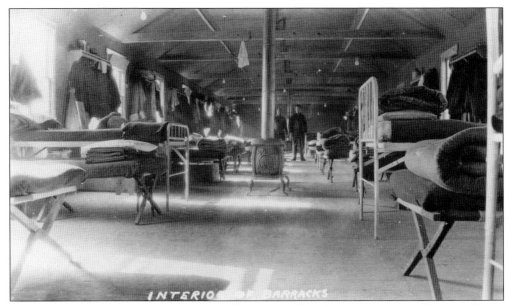

The camp had three barracks and occupied land owned by John C. Krumrine. The camp began with 50 to 60 men and had nearly 200 at its peak. Water for the camp came from a nearby mountain spring. A five-kilowatt generator provided electricity. The original buildings are now gone. (UCHS 92.4.89.5.)

On the site of the former CCC camp at Weikert now stands the Union County Sportsmen's Club on Weikert Road. The club was formed in 1944 and is known for its wildlife exhibits, shooting range, and good food. (Courtesy of Jim Walter.)

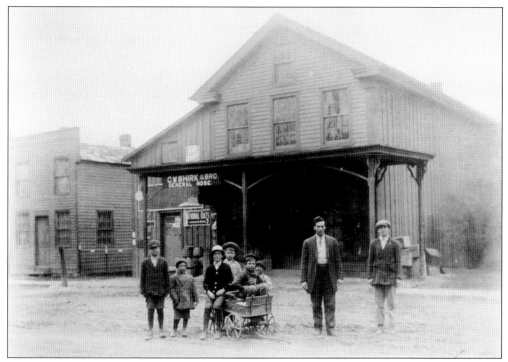

The general store in Hartleton is seen here about 1920. C.W. and Stuart Shirk were the proprietors. From right to left are Tom Printzenhoff, Richard McKissett, Roy Yarger, John Wilson, Paul Orwig, Clayton Shirk, and Dewey George Wolf. The small-town general store met almost all the shopping needs of the typical household. (Courtesy of Tony Shively.)

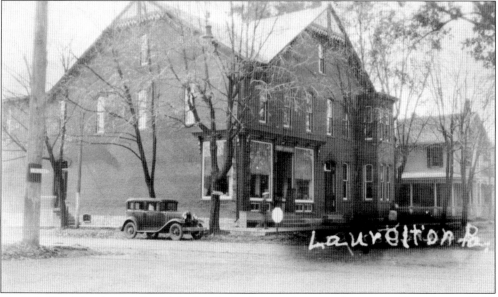

David R. "Pete" Pursley purchased the Raudenbush general store in the center of Laurelton in 1908. Pursley operated the store for 51 years until 1959. It was later owned by William Chappell and then by Merrill Buoy. Buoy later moved his store into a new building north of town. The old store building has been converted into a multi-family dwelling. (Courtesy of Ronald Nornhold.)

The gristmill seen on this 1914 postcard was built in 1839 by George Braucher on Laurel Run and handled much of the grinding for a large area. The mill operated under various owners, and by 1920 it was owned by Henry Herbster and his son Andrew. It remained in the Herbster family until it ceased operations in December 1961. (Courtesy of Ronald Nornhold.)

In this undated photograph, the Laurelton Flour Mill delivery wagon advertises its Excel Flour on the side of the driver's seat. The driver was Andrew Herbster, who also owned the mill. (UCHS 86.16.1.)

Three

CELEBRATING

Mountain forests and streams provide great outdoor recreation, and Union County offers both within a context of rural towns and spacious countryside. Celebration, that wonderful relief from work and routine, takes many forms. Towns celebrate national holidays with parades and picnics and their own specific history with centennials, anniversaries, and ethnic remembrances. Early on, the lumber railroads helped out, transporting townsfolk with picnic baskets and buckets for berry picking into the mountains. They created a leisurely journey for family and friends and managed the logistics of getting there. How joyful it was to take a day off to see the countryside, enjoy the mountains, or relax in a hunting camp's hammock.

There were other ways to enjoy the fruits of one's labor. The area sprouted hotels and restaurants for family and club events; local theaters brought in movies and even the occasional lecturer; town bands, high school bands, string bands, and cornet bands also gave performances and marched in parades. Small towns even had their own sports teams, especially baseball teams, and the high school launched football teams. Girls and boys participated in scouting and enjoyed the friendships made in summer camps. Hunting camps and summer houses dotted the mountain landscape, and Penns Creek offered fishing, boating, and water fun.

As time went on, celebrations became more elaborate. Mifflinburg offers a multi-day Christkindl Market celebration; a springtime Buggy Day; a Fourth of July celebration with all-day eating and evening fireworks; a summer evening for the Blueberries and Bluegrass Festival; a five-day Fireman's Carnival; summer Concerts in the Park; the fall weekend Oktoberfest; and a December Holiday House Tour. The West End, just north of Laurelton, puts on the weeklong West End Fair, a celebration of agriculture and farming skills, eating and entertainment, and vendors and a beauty pageant! The building of community depends on cooperation in work and play, and the communities of Mifflinburg and the West End have forged strong bonds enjoyed in celebration.

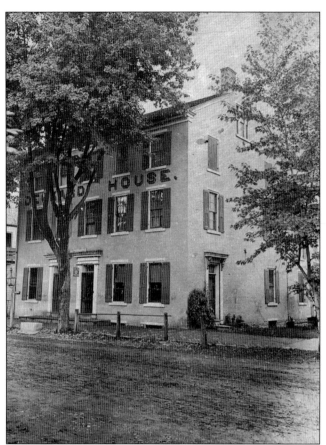

A hotel at 264 Chestnut Street was erected by the John Stitzer family in 1858. The Jacob Deckard family managed it for decades, shown here as the Deckard House. It was damaged by fire in 1916. The building was then restored, and a balcony was added in front. It was a temperance hotel when the county went dry in 1915. (MBM SC.)

The Deckard House was sold in 1916 by Herbert Deckard to Alfred A. Hopp, also owner of the Hopp Carriage Works, and operated as Hotel Hopp. Under the subsequent ownership of Agnes Geyer, mother of Hannah Kistler, it was renamed Hopp Inn. Hannah received ownership after her mother died, but she had long managed the property and was famous for her Sunday chicken dinners. (UCHS 89.5.13.2.)

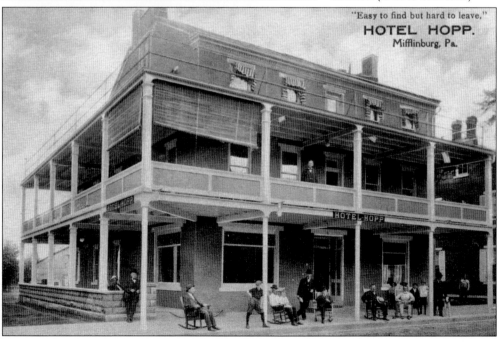

The kitchen of Hotel Hopp, "where good things come from," is pictured above in 1919. With the large stove and working table, Hannah Kistler (foreground) and her staff turned out dinners fit for the elegant dining room and white tablecloths where "There's always a place set for you." The dining room is seen below in the 1920s. The Hopp Hotel became Hopp Inn and later the Mifflinburg Hotel. Today, it includes the Scarlet D Tavern. Abby Scholl operated a soda fountain in the hotel in the 1950s. Before the move to the new Mifflinburg High School, students would walk to the hotel for lunch and an ice cream sundae. (UCHS 2006.9 and 97.1.15.)

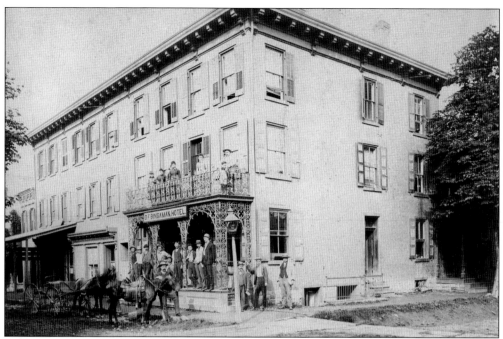

The Bingaman Hotel, originally the Buffalo Valley Inn, was built in the 1860s for William Young, a prominent businessman. Throughout the following decades, the name changed with every new owner. It was a temperance inn, and the *Mifflinburg Telegraph* reported in 1913 that the new owners hoped to have it patronized by "commercial men who like good 'feed' and cozy sleep-inviting beds." (UCHS 2007.11.8.)

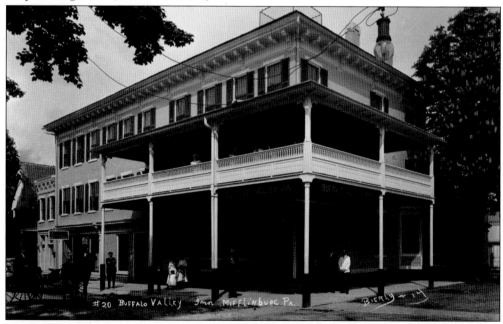

The Buffalo Valley Inn is shown here in 1915 after the porch was added and the front door moved from the side to the corner. The hotel closed during the Great Depression. Located at Chestnut and Fifth Streets, it has since been converted into office and apartment space. (UCHS 83.48.6.)

Immediately west of the Buffalo Valley Inn was Hoover's Restaurant. J. Hoover stands to the right with his white apron. The restaurant also offered billiards and cigars as well as food. Farther to the west was a barbershop with its identifying barber pole. The man shown on the doorstep is perhaps George Royer, the barber, waiting for a customer. (UCHS JD.)

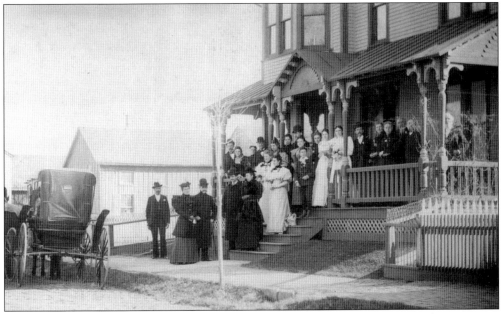

The wedding of Louise Kurtz to Thomas C. Hare of Altoona took place at 411 Walnut Street in Mifflinburg on November 28, 1894. The house was built in 1887 by Luther Kurtz, a Civil War veteran from Aaronsburg. Kurtz stands at the edge of the sidewalk. His two sons, Newton and Kreider, later operated an overall factory, established in Mifflinburg in 1898. (Courtesy of David Goehring.)

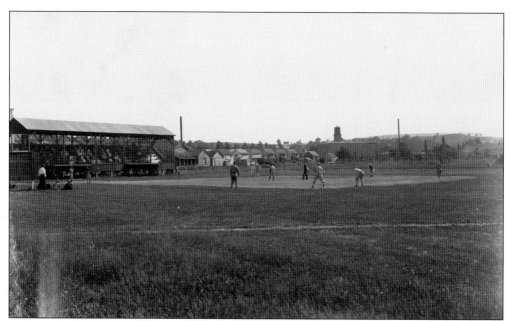

The Mifflinburg Fifth Street baseball diamond and grandstand was completed about 1905. Baseball was first organized in Mifflinburg by 1903, and the town team used the name "Country Club." The baseball diamond occupied the site of the current community park and is seen here about 1920. The Mifflinburg Country Club baseball team played against Lewisburg and New Berlin in the 1920s. (UCHS JD.)

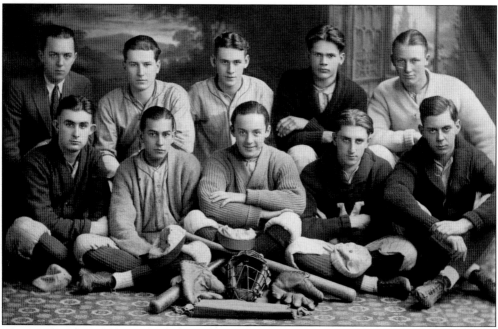

The Mifflinburg High School baseball team poses here in 1923. The players are, from left to right, (first row) Thomas Beckley, Harold Wise, Clair Brungard, John Sechler, and Harry Gutelius; (second row) William Sterling, Charles Lontz, Miles Huntingdon, Clair Ruhl, and Alvin Barber. (UCHS 95.37.2.)

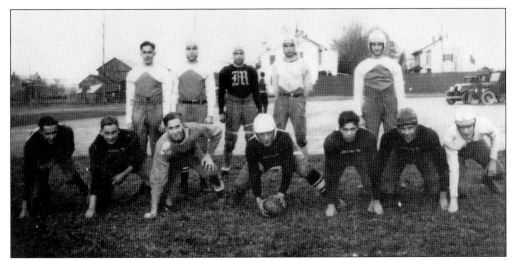

Mifflinburg High School included football among its athletic programs. The 1931 senior players of the football team were, from left to right, (first row) Charlton "Steve" Diffenderfer, Kenneth Erdley, Myron Eberhart, Rufus Jamison, Clifford Grove, Nelson Chambers, and James Barnitz; (second row) Thomas Houghton, Curwin Seasholtz, Robert Beckley, Leroy Minnick, and Charles Hemenway. The football team disbanded after 1931 and was not revived again until 1946. (Courtesy of Kenneth Erdley.)

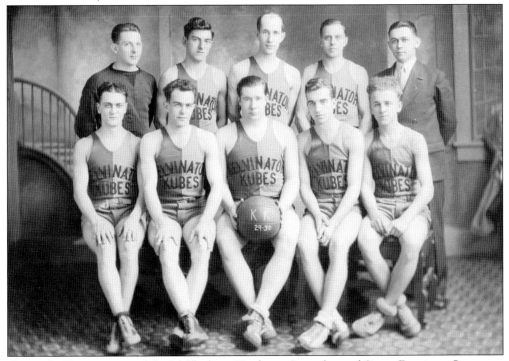

George L. Grove, owner of the Mifflinburg Hardware Store, later of Grove Furniture Company, and also a seller of Kelvinator appliances, sponsored the Kelvinator Kubes, a town basketball team. Pictured in 1929–1930 are, from left to right, (first row) Budd Rothermal, Earl Thomas, Doc Arnold, Cool Snyder, and Gordy Klingman; (second row) Mr. Leitzel, Frankie Royer, Fay Badger, Frank Boyer, and George Grove. (Courtesy of Jeanne Grove Zimmerman.)

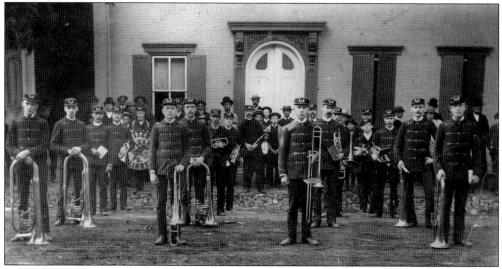

Just as towns had their own home sports teams, they also often had their own bands. The Citizens Band of Mifflinburg, pictured here around 1890, was directed for a time by Jack P. Higgins. Identified are John Wesley Gutelius, located at the far left, and Joseph Keen Gutelius, standing in the gutter at the back of the far right column. (UCHS 1994.32.91.)

The Patriotic Order Sons of America organized a new lodge in Mifflinburg about 1915. Lewis Rudy was the drummer boy. Dressed in military-style uniforms, the lodge participated in parades and other civic celebrations. With its motto "God, Our Country and Our Order," the organization stands for education, patriotism, and respect for the American flag. (UCHS JD.)

How about lunch out at the Hopp Inn with a dessert from the bakery? On this day around 1915, the staff stands ready to serve, including the cooks and proprietor Hannah Kistler in the dark dress with her young daughter Julia. (UCHS 2003.2.6.)

Wehr's first dairy store was a great place for ice cream on a hot day. In the late 1930s, Wehr's Dairy started to make ice cream, and the Wehrs opened this roadside dairy store, which also sold light lunches. They later expanded the menu to include dinners. Sunday chicken and waffle dinners were the specialty. (Courtesy of Glen Zimmerman.)

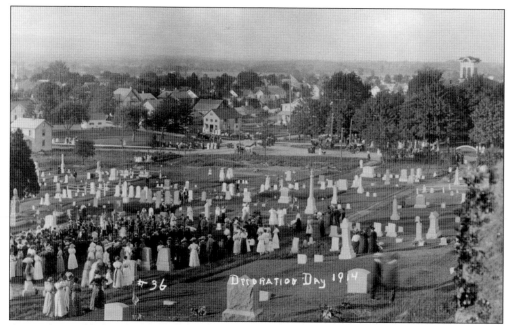

A crowd assembled in the Mifflinburg Cemetery in 1914 following the Memorial Day (then called Decoration Day) parade and prior to a service at the high school. The cupola of the high school is seen above the trees on the far right. (UCHS 85.7.3.)

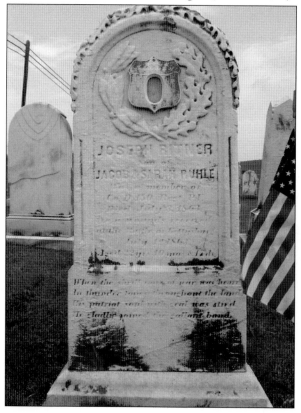

Joseph Ruhl fought in the Civil War with Company D of the 150th Regiment. He was wounded on July 1, 1863, in the Battle of Gettysburg, and died the next day. When word of his death reached home, his sister Sara hitched a wagon to go to the battlefield. She found his shallow grave, uncovered it, and carried his body home. He was reburied in Ray's Church Cemetery. (MLH.)

This World War I celebratory parade was held behind the Mifflinburg Public School building. Teachers instructed their pupils to line up appropriately with American flags in hand. Each student was also outfitted with a hat. John Brown's barn, located behind his house on Maple Street, can be seen in the background to the left. (MBM SC.)

The Shakespeare Club, an early Mifflinburg literary club, flourished from 1908 to 1915. The members are pictured here at a picnic at Woodward, Pennsylvania. They are, from left to right, (sitting) Mrs. Lybarger, Rev. Henry Calkins, Mrs. Calkins, Martha Doebler Halfpenny, Frances Shriner Ruhl, Matilda Kessinger, and Carrie Mensch; (standing) Fred Klose, Margaret Lodge, Mrs. Pellman, Lee Francis Lybarger, O.K. Pellman, and Paul Halfpenny. (Courtesy of the Ruhl family.)

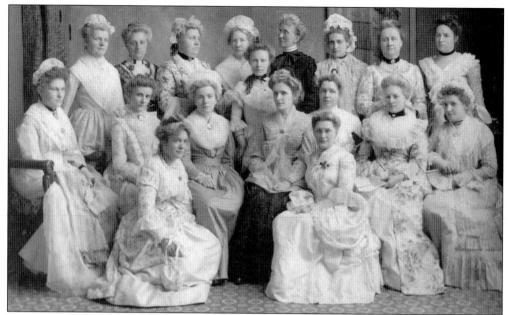

The Twentieth Century Club, established at the turn of the century, met monthly, when members presented papers on world literature. On this day in the early 1900s, the women celebrated George Washington's Birthday by dressing as Martha Washington. Identified are Frances Shriner Ruhl, standing far left; Annie Wolfe, standing fourth on left; and Margaret Lodge, seated second on left. (Courtesy of the Ruhl family.)

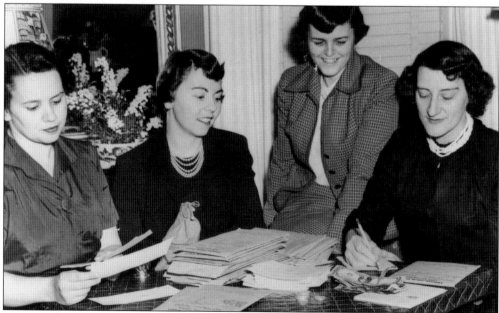

The Civic Club began as the Junior Athenaeum Club and first met officially in 1946. It worked to serve the community, and its projects included petitioning for a kindergarten, sponsoring Halloween parades, erecting street signs, and distributing food baskets to the needy at Easter. Seen here in the 1950s are Civic Club members (from left to right) Helen Pfleegor Strunk, Jeanne Grove Zimmerman, Laura "Patty" Kurtz Minium, and Rose Tauro Edelman. (MBM SC.)

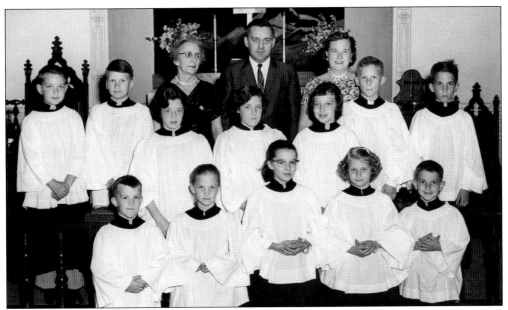

Church choirs also display the county's talent. The Ray's Church Cherub Choir members, posing in 1959, are, from left to right, (first row) Brian Eberhart, Susan Willow, Linda Fox, Gail Erdley, and Jerry Inch; (second row) James Sanders, Gary Shoemaker, Beverly Walters, Sharon Walters, Beverly Inch, Terry Willow, and Samuel Willow; (third row) Miss Margaret Ruhl, organist; Rev. Marion E. Smith, Reformed pastor; and Mrs. Marion E. Smith, director. (UCHS 2011.10.18.)

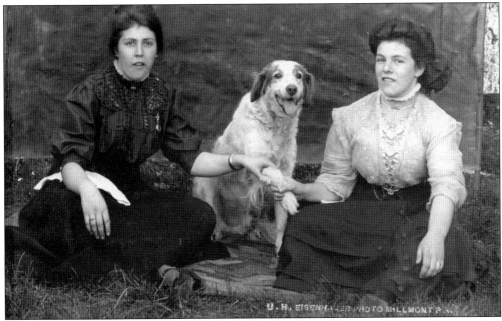

Photography celebrates life's important moments. Urs H. Eisenbhauer, a Millmont photographer, produced this 1909 photograph as a postcard. Almost smiling, Florence Smith (left), Mazie Fessenden, and the dog Rover look a little informal. The message on the reverse side even mentions looking "natural" and reads, "Here is a card for your album do we look natural. Now ans[swer] this card or we will never send another one ha ha." (UCHS 2007.11.15.)

The first Buggy Day celebration took place on Memorial Day weekend in 1981. An event of major importance for industrial history buffs was the "discovery" in the mid-1970s of the preserved W.A. Heiss Coach Works. Opened to the public in 1979 as part of the Mifflinburg Buggy Museum, the buggy factory has drawn visitors ever since. (MBM SC.)

Mifflinburg Buggy Day is seen here on Market Street in 2002. For several years, the celebration included craft and flea market vendors. More recently, Buggy Day is a celebration of the Mifflinburg Buggy Museum and the history of buggy making. The day is held in conjunction with International Museum Day in mid-May. The open house includes demonstrations of blacksmithing, chair caning, and needlework. (MBM.)

Traditional German nutcrackers guard the entrance to the Mifflinburg Christkindl Market. Founded in 1989 by Rudi and Joannah Purnell Skucek, it is modeled after the traditional German outdoor *Christkindlmarkt* (Christmas market) and celebrates the German heritage of the community. The annual December event fills three blocks with wooden huts for food and craft vendors. Adjacent churches provide venues for holiday music performances and a place to warm up. (MLH.)

Shoppers enjoy finding their treasures. Over 100 vendors line the streets selling mainly handmade crafts and ethnic foods, such as apple dumplings, Hungarian goulash, *Apfelstrudel* (apple strudel), and *Glühwein* (hot mulled wine). Moravian stars and pine boughs decorate the huts. Between 10,000 and 15,000 people are estimated to attend this holiday event. (Courtesy of Joannah Skucek.)

Christkinkdl Market town crier Larry Mitchell (left) and setup chairman Jim Ranney converse in front of a live nativity scene surrounded by a silhouette display of community churches. Three and a half days of intensive setup with full support of the borough crew, assistance from local prison inmates, and dedicated volunteers create this market year after year. (MLH.)

Eating one's way through the market with lots of friendly encouragement is a Christkindl favorite. The crisp cold air is filled with aromas of apple dumplings, Hungarian goulash, Apfelstrudel, Glühwein, kettle corn, homemade soups, bratwurst, and baked pretzels. Community and holiday spirits are at their peaks. (MLH.)

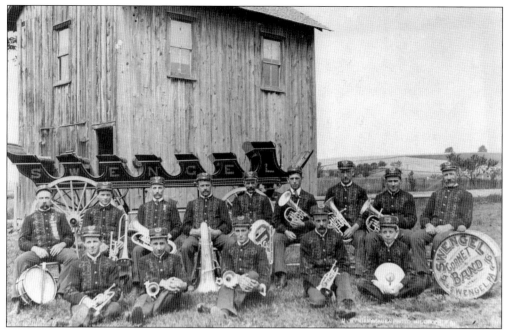

The Swengel Cornet Band was organized in 1884 under the direction of Isaac Zellers of Mifflinburg. Charles Hursh, one of the Hursh buggy-makers in Mifflinburg, and Milton Halfpenny built the famous bandwagon. The band room was on the second floor of the building; the bandwagon was housed on the first floor. The group disbanded around 1919. (UCHS.)

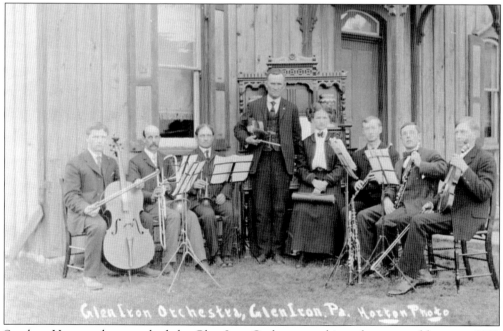

Stephen Horton photographed the Glen Iron Orchestra and issued a postcard between 1907 and 1911. The members are, from left to right, Bud Zimmerman, Charles Knauss, Milton Keister, Calvin Osman, Hattie Osman, Reno Bowersox, Harry Olmstead, and Edmund Yarger. (Courtesy of Ronald Nornhold.)

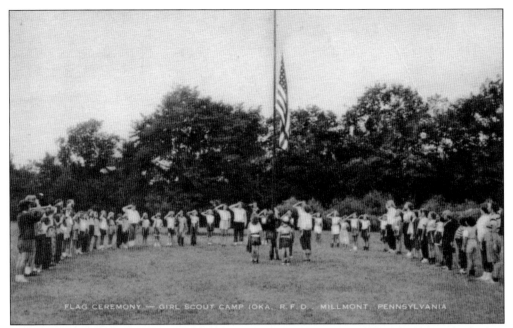

Formal flag ceremonies were held daily at Camp Ioka in the early morning and again in the late afternoon before dinner. The girls were expected to wear their green Girl Scout shorts and white blouses. The lead flag bearers also wore red sashes across the shoulder. The flag ceremony took place in front of Tasker Lodge. (UCHS 97.3.7.)

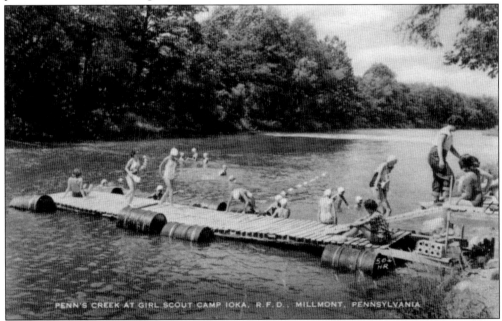

Camp Ioka, meaning "peaceful place by the stream," was established in 1947. Located three miles west of Glen Iron and previously known as Jack's Mountain Camp, the facility provided weeklong outdoor camping experiences for Girl Scouts until 1987. Swimming in Penns Creek in the early 1950s, the girls wore different colored caps based on their swimming ability. (Courtesy of Ronald Nornhold.)

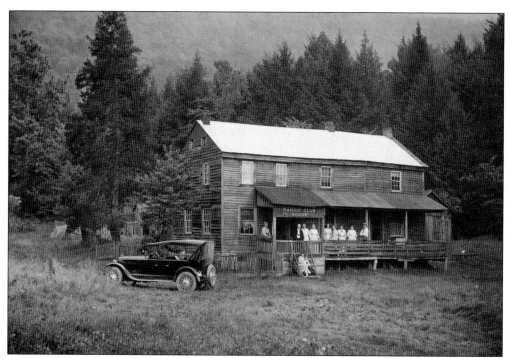

In the 1920s, the Foster family traveled in their seven-passenger Chandler to a camp on the south side of Penns Creek, east of Millmont, for an outing. The Rarick Clubhouse was large enough to accommodate a number of visitors as they vacationed in the country. The West End became increasingly valued as a rustic summer cabin and camping destination. (UCHS 1994.32.93.)

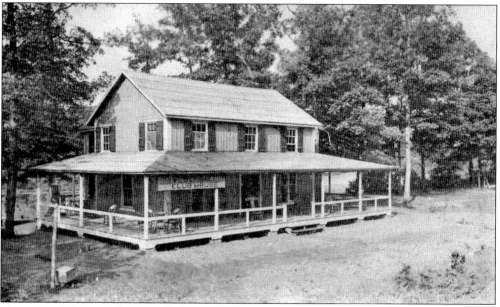

Camp Westfall, two miles west of Glen Iron along Penns Creek, is seen here before later alterations that removed the eastern end of the veranda. The Lewisburg & Tyrone Railroad once ran parallel to the campsite, and accommodating engineers would, upon request, stop long enough to pick up or discharge passengers. (UCHS 86.1.6.3.)

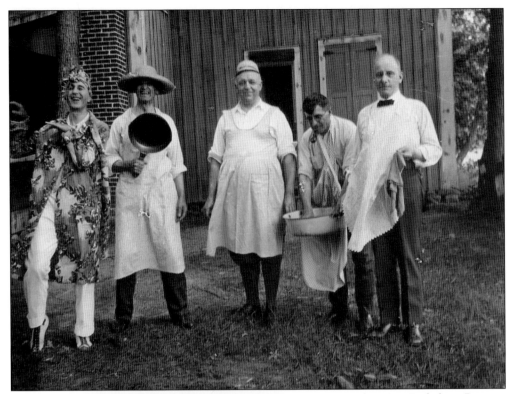

Camps in the West End along Penns Creek were great places to relax and have fun. It is no wonder people looked forward to the days spent at camp and in summer cabins. Pictured here from left to right, Kreider Kurtz, Guy Roush, David Van Dueson, Newton Kurtz, and David L. Grover strike a playful pose at Camp Westfall, Hartley Township, in the 1920s. (Courtesy of David Goehring.)

The fishing was good in 1938 at Camp Westfall. Newton A. Kurtz teaches his great-nephew Raymond R. Goehring Jr. how to get a good catch on Penns Creek, and it seems that they were successful. Hunters roamed the area in the late fall, looking for that elusive deer or even a black bear. (Courtesy of David Goehring.)

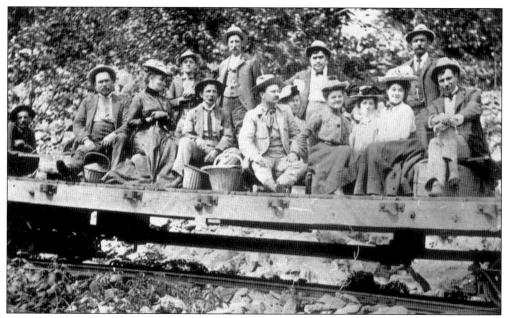

The Laurelton Lumber Company provided transportation for outings and picnics to the West End. On this outing on Memorial Day weekend in 1902 were, from left to right, (seated) Charles Mohn and his wife Laura (with parasol), Samuel Rutherford, three unidentified, Clara Pursley (head shows), Florence Rutherford, and Dr. Oliver W.H. Glover. Other than Pete Pursley with the bow tie, those standing are unidentified. (UCHS 89.5.14.16.)

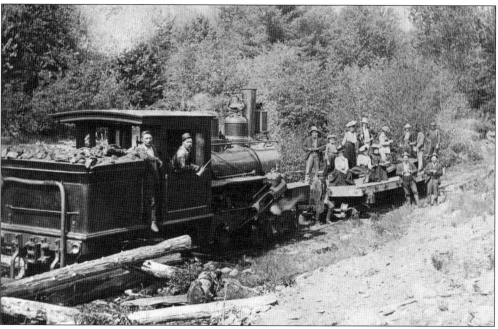

Another outing in the early 1900s was provided by the Pardee logging railroad. During good weather, the train engine transported passengers on a log car for picnics or huckleberry picking. Huckleberries grew profusely throughout large stretches of the mountainous terrain once the canopy of the trees had been removed. (UCHS 2010.21.180.)

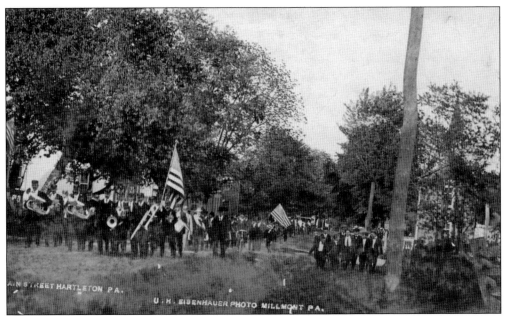

Eleanor Hoy remembers Memorial Day in Hartleton in the 1930s. The evening before, people brought flowers from their gardens to make bouquets. These were given to children who decorated the graves of the Union Church Cemetery. Then, the children were given another bouquet and marched with parents and townsfolk, along with the Millmont Band, to the Hartleton Hill Cemetery. (From the *Millmont Times*, June 2004; UCHS 87.7.11.)

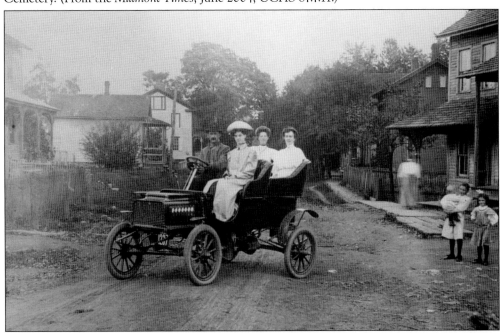

Harry Fauver's red 1904 Rambler Model H with its rear entrance tonneau was an attraction in Laurelton about 1905. Essie Peck VonNeida (in the middle) and two Brenner girls (Harry's nieces) were privileged to ride while Frances Sampsell (holding a baby) and her sister Marcella watched. Between 1903 and 1905, there were 12 car registrations in Union County. (UCHS 89.5.11.13.)

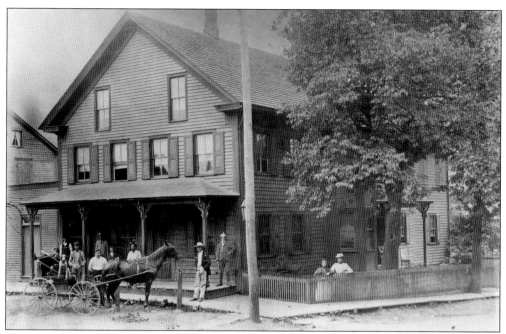

The Pursley Hotel, also known as the West End Hotel, stood on the site of the present Laurelton post office. The building burned down on October 26, 1922, and was never rebuilt. The hotel had been owned by James Pursley and later by his son Pete Pursley. At the time of the fire, Martin Emery operated a store on the first floor and resided on the second floor. (UCHS 89.5.35A.)

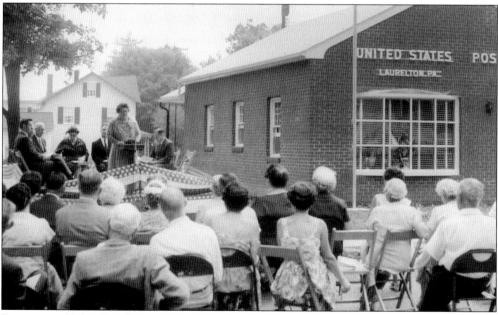

Postmaster Helen Pursley Harter speaks at the dedication of the Laurelton Post Office on August 5, 1961. Seated behind her are, from left to right, David Pursley; the Honorable J. Irving Whaley, US Congress; R.F.L. May, postal field officer; Ruth Miller Steese; the Reverend Marlin Haines of the Holiness Church of Glen Iron; and U. Menzie, chaplain of Laurelton State Village. (UCHS 1999.5.1.)

The West End Fair in Lincoln Park began in 1926 as a "homecoming picnic" to entertain visiting former residents. The Lincoln family donated the land for Lincoln Park, and the park expanded to accommodate ever larger fairs. The grounds now include a large building for non-livestock exhibits, a dairy barn, and covered stage. Seen here are volunteers setting up the fair in 1969. (Courtesy of the West End Fair Association.)

Located in the country, the cow flop contest, seen here in the 1970s, was a demonstration of the skill at hurling, as far as one could, what the cow has, well, plopped. The top prize for this athletic prowess was a rosette ribbon. This particular contest is no longer held. (Courtesy of the West End Fair Association.)

The Miss Union County Pageant began at the West End Fair in 1965 and continued until 1988. It was revived for the 75th-anniversary celebration in the year 2000 and has continued ever since. The Sun Area Dairy Princess, Carol Walter Bowersox (front left), and Miss Union County, Vicki Lewis Yost, stand with the 1976 dairy cow winners, from left to right, James, Harry, and Donald Sanders. (Courtesy of the West End Fair Association.)

The tractor pull competitions are favorite events at the West End Fair. In this 1973 contest, one can almost hear the tractor whine as fans cheer the driver on. The fair's tractor pulls include different weight classes for lawn tractors to big farming tractors. (Courtesy of the West End Fair Association.)

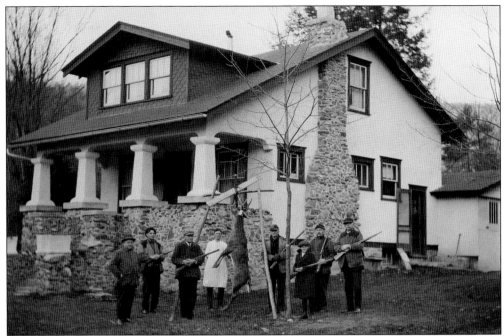

Pictured sometime between 1925 and 1930, a group poses at Orwig Hunting Camp on the Seven Mile Narrows. The camp's owner, Horace Orwig, stands at the far right. Carl Hassenplug is second from the left, and to the right of him stand William Shaffer and Joseph C. Foster. The Seven Mile Narrows is the stretch of Route 45 that leads through the mountain pass, east of Laurelton State Village, and into Centre County. (UCHS 1994.32.92.)

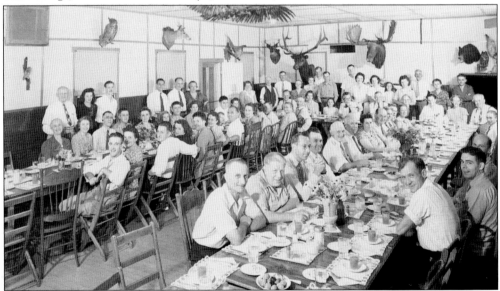

On July 8, 1946, the Union County Sportsmen's Club held a birthday party for Andrew Herbster, a prominent Laurelton feed mill owner and first president of the club. It was through Herbster's perseverance and determination that the Union County Sportsmen's Club became a reality. He was an avid hunter and fisherman; many others sought his advice and viewed his drive and energy as legendary. (UCHS 88.4.C46.8.Da.)

AFTERWORD

Mifflinburg and the Buffalo Valley's working farms, tended by a growing plain sect population, will continue to define Union County's agriculture and small-town tradition for generations, even as moderate population growth occurs. The historic transportation connection derived from its success as a buggy town, being a former railroad stop, and location on the "old turnpike" continues as Mifflinburg evolves into a "trail town." The Buffalo Valley Rail Trail, which is on a portion of the original Lewisburg, Centre & Spruce Creek Railroad, will spur elements of tourism, commerce, and business investment as it offers nonmotorized travel, recreation, and an enhanced quality of life. Mifflinburg is poised for ongoing community success. Its authenticity, which values its history as it develops to compete in today's economy, increasingly attracts people who are frazzled by the demanding lifestyle of more populated areas.

The prosperity of the West End that flourished during the timber boom and from proximity to the old railroad is a bygone era. The closing of the Laurelton State Center eliminated the last major employer, and West End prominence is unlikely to return quickly. What lies ahead for Swengel, Millmont, Glen Iron, Weikert, Hartleton, and Laurelton will build on what exists today with thousands of forested acres, farmland, and open space surrounding these hamlets and villages that seem to promise a slower pace of living. Like the past, the future success of this area is dependent on the conservation of its natural resources, its location, and the resolve of its people. The West End will remain a home for rural enterprise centered on agriculture and forestry, and a place for people from near and far to connect with nature in the Bald Eagle State Forest, through a growing cabin culture and the lure of Penns Creek.

—Shawn McLaughlin, Director of Union County Planning

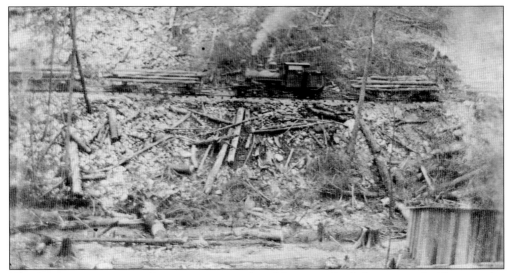

The logging tramways and narrow-gauge railroad lines reached their tentacles far into the mountains. This 1901 photograph shows an engine with a load of mine props near the end of the Pardee Lumber Company operation. The ruthless cutting on the mountainside left waste and bare soil without thought of remediation. (UCHS 2010.21.180.)

Raymond B. Winter, photographed in front of the lake at Halfway Dam in the 1950s, had a vision for a state park system. He dedicated his 45-year career to healing the scars made by the timber industry to vast tracks of forestland. His early work establishing what became R.B. Winter State Park in Hartley Township was greatly helped by the Civilian Conservation Corps in the 1930s. (Courtesy of the Bureau of State Parks.)

BIBLIOGRAPHY

Bastian, Jonathan. *Lumbering—A Way of Life at Pardee 1886–1903*. Mifflinburg, PA: privately published, 2005.

Blake, Jody, and Jeannette Lasansky. *Rural Delivery: Real-Photo Postcards from Central Pennsylvania, 1905–1935*. Lewisburg, PA: Union County Historical Society, 1996.

Deans, Thomas R., ed. *The Story of a County: 1813–1963*. Lewisburg, PA: Union County Sesquicentennial Committee, 1963.

Historic Preservation Plan of Union County, Pennsylvania. Part I: An Inventory of Historic Sites and Landmarks. Prepared by the Institute of Regional Affairs at Bucknell University for the Union County Planning Commission, Lewisburg, PA: Union County Planning Commission, 1976.

Kalp, Lois. *A Town on the Susquehanna, 1769–1975*. Lewisburg, PA: Lois Kalp, 1980.

Linn, John Blair. *Annals of Buffalo Valley, Pennsylvania, 1755–1855*. Harrisburg, PA: Lane S. Hart, 1877.

Lontz, Mary Belle. *History of the Schools of Union County, Pennsylvania*. Lewisburg, PA: Mary Belle Lontz, 1984.

Mifflinburg Telegraph, Mifflinburg, PA.

Millmont Times, Millmont, PA.

Snyder, Charles M. *Mifflinburg: A Bicentennial History*. Mifflinburg, PA: Charles McCool Snyder and Mifflinburg Bicentennial Committee, 1992.

Snyder, Charles M. *Union County Pennsylvania: A Celebration of History*. Lewisburg, PA: Union County Historical Society, 1976; revised and updated edition, 2000.

DISCOVER THOUSANDS OF LOCAL HISTORY BOOKS FEATURING MILLIONS OF VINTAGE IMAGES

Arcadia Publishing, the leading local history publisher in the United States, is committed to making history accessible and meaningful through publishing books that celebrate and preserve the heritage of America's people and places.

Find more books like this at
www.arcadiapublishing.com

Search for your hometown history, your old stomping grounds, and even your favorite sports team.